PEN AND INK

Brimming with creative inspiration, how-to projects, and useful information to enrich your everyday life, Quarto Knows is a favourite destination for those pursuing their interests and passions. Visit our site and dig deeper with our books into your area of interest: Quarto Creates, Quarto Cooks, Quarto Homes, Quarto Lives, Quarto Drives, Quarto Explores, Quarto Gifts, or Quarto Kids.

First Published in 2016 by Frances Lincoln Limited, an imprint of The Quarto Group, The Old Brewery, 6 Blundell Street, London N7 9BH, United Kingdom. T (0)20 7700 6700 F (0)20 7700 8066 www.QuartoKnows.com

Library of Congress Cataloging-in-Publication Data available.

ISBN: 978-0-7112-3804-6

Manufactured in China.

10 9 8 7 6 5 4 3

Publisher: Mark Searle
Editorial Director: Isheeta Mustafi
Commissioning Editor: Alison Morris
Editor: Nick Jones
Junior Editor: Abbie Sharman
Cover Design: Agata Rybicka
Layout: Kate Haynes

Cover Pictures (Left to right):

Front:
Pamela Grace, Sabine Israel, Chris Lee, Joan Ramon Farré Burzuri, Jedidiah Dore, Michael Lukyniuk, Loui Jover, Marina Grechanik

Back:
Fred Kennett, Caroline Didou, Ramon Farre, Loui Jover

PEN AND INK

CONTEMPORARY ARTISTS, TIMELESS TECHNIQUES

JAMES HOBBS

F

FRANCES
LINCOLN

Flicking through this book

In addition to the contents listing opposite, we have included artist and visual indexes to help you dip in and out of this book. Use these to find specific information or sketches quickly.

Visual index

Because this book is as much about visual inspiration as it is about technique, we have included a visual index on **pages 6–9**. If you are trying to find an image you have already seen in the book, or looking for a specific style, colour or background, use this to take you straight to the right page. Page numbers are given on the thumbnail of each sketch. Please note that where more than one drawing is included in an entry, only one is included in this index.

Artist index

If you'd prefer to search for images via the artists, an index listing artists alphabetically by last name is on **pages 204–205.** Here you will find a full list of the pages their art appears on and also blog or website details if you'd like to check out more work.

CHRIS LEE, LINZ, AUSTRIA
Medium: pigment pen and watercolour
Dimensions: 20 x 28 cm

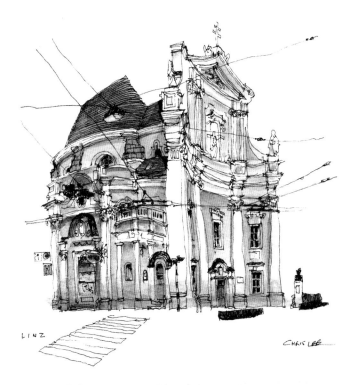

LINZ

CHRIS LEE

63
71
79
85
93
99

65
73
81
87
95
10

67
75
89
97
10

69
77
83
91
10

153

161

169

175

183

189

155

163

177

185

191

157

165

171

179

187

193

159

167

173

181

195

What is pen and ink?

Pen and ink has stood the test of time. At its heart is the simple act of dipping a stick into a pot of pigmented liquid to make a line on paper, or some other surface, and that process has, in essence, remained unchanged for centuries. Ink was developed in Egypt and China more than 4,000 years ago, and has been central to East Asian culture for many centuries through calligraphy and drawn imagery. In the West, the heritage has continued through the works of Leonardo, Michelangelo and Rembrandt, to Picasso, Warhol and Mehretu.

Whereas artists from, say, seventh-century China were limited in the range of materials they could turn to for their creative endeavours, in the twenty-first century there is a huge and growing number of options to make a two-dimensional work, the most recent being drawing apps on phones and tablets. So why should we use pen and ink now?

Its simplicity and affordability is a great appeal. It is a medium that can be as humble as doodling with a ballpoint pen on the back of an envelope. It can be as streamlined as a single fineliner pen and a small sketchbook that slips easily into a bag or inside pocket of a jacket. It certainly isn't an expensive medium to employ unless you choose to acquire the widest range of products on the market.

Ink's beautiful blackness and permanence also sets it apart. Opaque dark marks appear in long, fluid lines, resisting erasure. Ink doesn't need fixing to the paper as some dry media do. Marks are decisive and bold, and you have to learn to live with them.

FRED KENNETT, SACK THE SIGNWRITER
Medium: technical pens
Dimensions: 35 x 50 cm

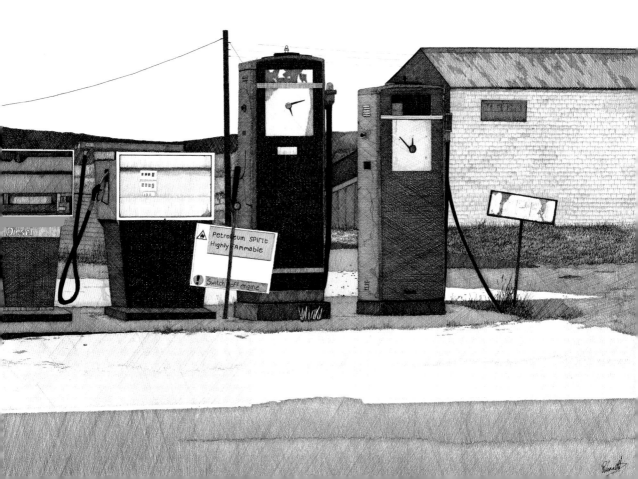

It is a medium that encourages a confident approach: you can make an underdrawing in pencil to plan a composition, but a work steeped in premeditation will probably not have the vitality and energy of a drawing done with ink first time. It is a medium that is a constant reminder of our failings, and yet it arms us to find our way around them.

It takes time to get to know a nib – the way it holds its ink, the way it unloads it and how it reacts to the paper. With a dip pen we must discover how long the ink will last before it needs reloading, and how pressure and the angle at which it is held and drawn can affect the quality of the line it makes. The constant, mechanised flow of ink from a felt-tip or marker pen can be seen as an advantage or disadvantage, and unpredictability of line can be a virtue. Drawing with twigs or bamboo pens can create some of the most distinct marks of all.

I drew with pencils for years before I turned to black marker pens. I love the organic quality of pencils, the great variety of weights of line and tone they offer, but

I found I prefer the emphatic blackness and permanence of ink coming from a thick-nibbed pen, and the expressive opportunities they give. They make me want to be bold, to turn white paper black in a way that the inherent sketchiness of even a soft-leaded pencil never can.

This book takes a broad view of pen and ink. There is now a vast array of disposable pens, some of them refillable or with dual nibs; there are fountain pens with cartridges and reservoirs, water-soluble inks, coloured inks and more. Many artists also use brushes in their pen and ink work to build up ink washes or add watercolours as a contrast to the drawn black line. This book embraces them all.

James Hobbs

**PAMELA GRACE,
STOOPS LOAMING**
Medium: inks with watercolour
Dimensions: 38 x 48 cm

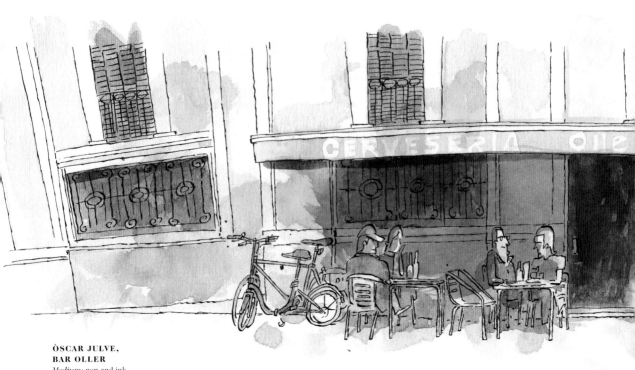

**ÒSCAR JULVE,
BAR OLLER**
Medium: pen and ink
Dimensions: 23 x 90 cm

A wide-angle view

Swasky

To look at this drawing is to feel as though you are teetering on the edge of a balcony, or looking through a wide-angle lens at the quiet Spanish village. The fish-eye effect means that we can see almost straight down to the street below, and right across to the distant rooftops opposite. It results in a cheerful distortion that captures the street's character in a web of lines and angles.

The strong element of pattern also catches the eye. The roof tiles are meticulously drawn and there are the striped lines of the awning over the bar, and the closed shutters. Electrical wiring passing from one side of the road to the other leads the eye around the picture, their lines doubled up by the inclusion of their shadows painted in a lighter tone wash.

Swasky found it impossible not to eavesdrop on the conversations he could hear from below while he worked: 'As I was drawing I discovered that someone had been to hospital, that the weather this year was great, that the bar's owner is from Majorca, and more stories that I'll keep to myself,' he says.

THE CROSS ROADS (WHERE YOU FIND OUT EVERYTHING)
Medium: fountain pen, brush and ink
Dimensions: 22 x 30 cm

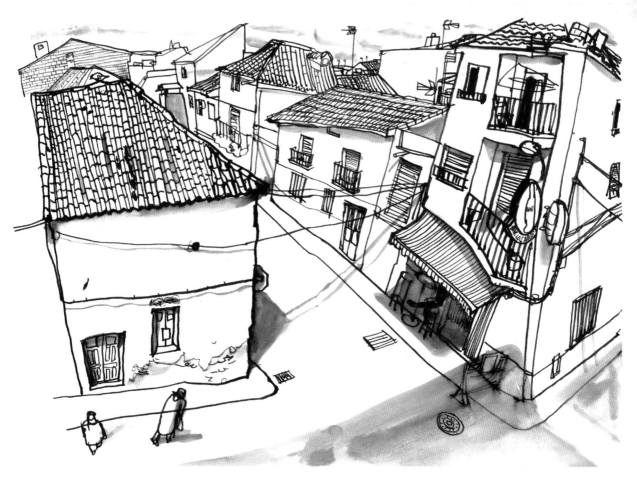

Modern-day hieroglyphics

Cachetejack

This drawing has been created by assembling scanned elements of a selection of still life compositions by Cachetejack and arranging them in Photoshop. The straightforward simplicity of the line that comes from a thick marker pen, compared with the subtler marks offered by, for instance, brush pens or dip pens, means that the subjects are stripped back to their most direct forms, becoming almost a form of modern day hieroglyphics.

The items – most of them familiar from everyday life, some more surreal – are immediately recognisable and yet reduced to their starkest outlines, which is accentuated further by the lack of colour or tonal variation. There is black and white, and nothing in between. 'The drawings are like symbols – everything is reduced to its simplest form,' the Cachetejack duo say. 'The effect we wanted was simple and descriptive. Marker pens let you keep drawing very easily and give the perfect feeling of a line.'

While permanent pens may leave no room for correction or adjustment, there is a degree of flexibility in choosing to arrange the drawings digitally. The cigarette symbol is repeatedly copied, rotated and pasted throughout the arrangement to bring a consistent element to the composition, which was used by the illustrators as the endpapers in a fanzine.

VANITAS
Medium: marker pen
Dimensions: 13 x 13 cm

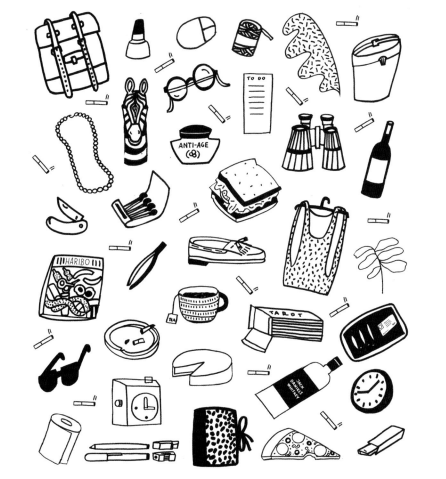

Finding expressive lines

Rolf Schroeter

What is the difference between drawing animals and people? Rolf admits that he can struggle with the anatomy of horses, but here he has approached the task just as he would have if he were drawing a human subject: through close observation.

A fountain pen with a fine, flexible nib has been used with waterproof ink on very thin and smooth 50 gsm paper. The subject has been composed on the sketchbook's page so that the foreshortened body of the horse sits on one side of its spine, and its head and tether lie on the other.

The drawing is a great example of how direct and nuanced pen and ink can be. There is a calligraphic feel to the lines describing the horse's back as they widen and then taper. The long descriptive arcs of its outline and the drooping quiff of the mane contrast with the lighter, flicked marks that represent hair on the legs, rump and nose. The drawing is about more than just the horse's character, but about the expressive act of drawing: it is possible to imagine the sweep and flick of the pen as Rolf draws from the marks he has made.

**WESENDAHL_
GINETTE_070315**
Medium: fountain pen
and waterproof ink
Dimensions: 13 x 18 cm

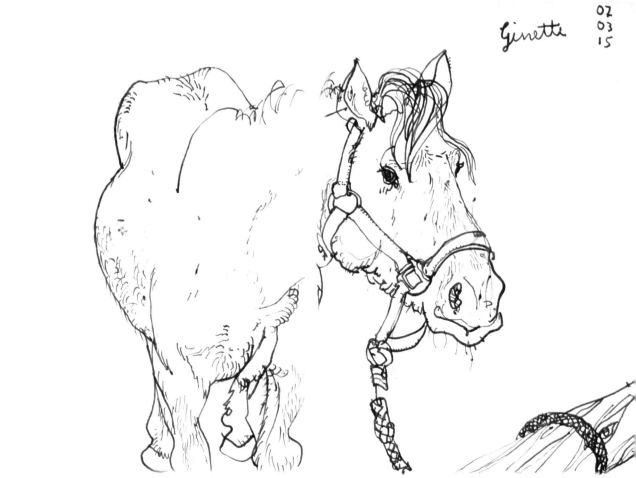

Ginette

07
03
15

People in motion

Nina Johansson

Drawing people in action, such as these musicians rehearsing together, can be a challenge, especially in pen and ink, as postures can come and go quickly. But by working on several drawings on the same sheet of paper at the same time, it is possible to move from one musician to another as their positions change, and return to them when each pose returns. The time spent waiting for a trumpeter's position to return is spent drawing the drummer, for instance. The page fills with an assortment of snatched portraits rather than a single overall scene, which matches the improvised nature of the rehearsal time.

Nina used a fountain pen with a nib bent at its tip – sometimes called a fude nib – that offers a variety of line widths depending on the angle at which it is held on the paper. 'This type of pen makes me more loose and free when sketching, because it's harder to get caught up in small details with it,' she says. 'If I use a fineliner I have a tendency to draw more details.'

HUDDINGE BIG BAND
Medium: fountain pen and carbon ink
Dimensions: 13 x 38 cm

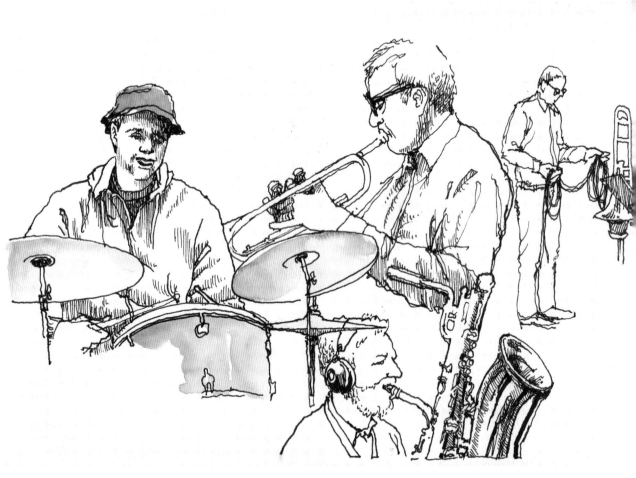

From the nib of a fountain pen

Marina Grechanik

There are many advantages to drawing with just a fountain pen. Simplicity, for a start. A single pen is so portable, and – along with a small sketchbook – is all that is needed to entertain the creative urge. The wealth of lines in this drawing of people relaxing in a park comes from the nib of just one fountain pen.

Fountain pens for artists vary in flexibility, cost and durability – finding the right one is a personal choice. With such a pen you invest in a relationship with its nib, and get to know how it reacts on different surfaces or if held in different ways. Marina has used here a waterproof ink that is suitable for use with fountain pens: India ink will generally clog the nib of a fountain pen when it dries, so it is worth considering dip pens, fineliners or felt-tipped pens as well. Some fountain pens come apart easily for rinsing and cleaning.

'I like using a fountain pen because it gives me the opportunity to be very graphic and bold in my sketches,' Marina says. 'Its lines are very strong, so you need to be very decisive.'

PICNIC AT SARONA
Medium: fountain pen
and waterproof ink
Dimensions: 23 x 30 cm

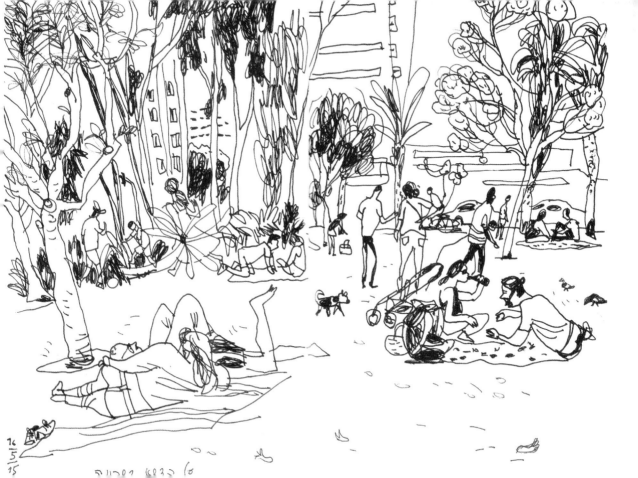

Brush pens at speed

Suhita Shirodkar

Brush pens are a convenient and effective way of bringing a variety of weights of line to a drawing from a single pen. A brush tip offers fine, light lines when its tip is applied to the page, but with pressure it can cover ground quickly and more boldly, and with a changing thickness of line. 'I draw with brush pens because they're a very portable form of pen and ink,' says Suhita. 'There is no set-up, no ink bottle to carry around and they are perfect for a quick response to something I see. They let me work quickly, loosely and gesturally.'

This 10-minute drawing shows Suhita's eight-year-old daughter engrossed in her piano practice. The energy and speed of the brush pen is apparent in the way the ink breaks up in some marks, letting the paper show through.

There are places also where it seems as if the pen hardly left the paper as the drawing progressed, such as around the hair, or the back of the dress; this can be a sign of an artist with a firm focus on looking closely and drawing what they see rather than what they think they see. Blue and ochre watercolour were added immediately, mixing on the paper. With a moving subject, speed is vital.

PIANO PRACTICE
Medium: brush pen and watercolour
Dimensions: 20 x 15 cm

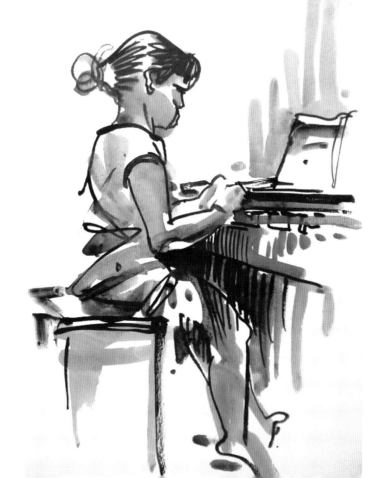

Drawing with a drying brush pen

Rolf Schroeter

Rolf worked in a notebook from behind a stall at a flea market he was selling goods at, drawing people as they passed by and gradually combining the figures in this single group over a period of about 25 minutes. The brush pen he used here, which has a refillable reservoir, allowed him to create a variety of marks by both changing the degree of pressure with which it was applied, and by altering the flow of ink by using it either quickly or slowly.

The flow is also influenced by how recently the brush pen has been filled: 'I used it for a long time nearly dry, enjoying the very light lines it made in this state before refilling it,' Rolf says.

'I like to use a brush pen, especially on suitable light papers, because of its variable and, if needed, strong impact. It allows us to capture items in a reduced, quick and expressive way, or to work out the fine details of other parts. So the drawing is not just an observation – no drawing ever is – but a selective interpretation.' The notebook, with thin, looped pages so sheets of paper could be inserted to prevent ink bleeding through, was a present, probably from Shanghai.

KIEZFLOHMARKT 1 181014
Medium: brush pen and waterproof ink
Dimensions: 25 x 25 cm

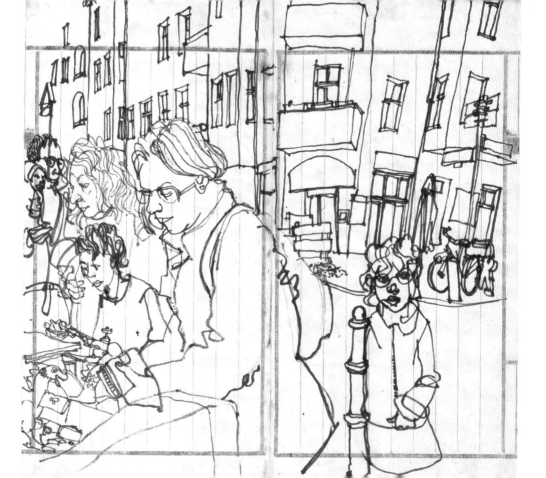

The soft lines of dry twigs

Ch'ng Kiah Kiean

Pen and ink is an excellent medium for bringing together a range of effects in one single drawing, as Kiah Kiean has done here to show a century-old Cantonese-style temple in the streets of the city of George Town, Malaysia. He has used dry twigs with waterproof Chinese ink to draw its soft, meandering lines.

Twigs from different trees will produce marks of varying effect. Hardwood twigs, for instance, create finer and harder lines than those made from softwoods. And they can be sharpened and shaped with a penknife when they become blunt, or when finer lines are required. Careful loading of the ink will prevent too much being applied to the paper too quickly.

Experimentation and patience, and a willingness to go, quite literally, with the flow, are recommended. The uniform line of mechanical conformity and an even flow – what we may expect from commercially available markers and pens – aren't what dry twigs are about, and that is their strength and why they are worth experimenting with.

NG FOOK THONG TEMPLE, CHULIA STREET
Medium: dry twigs with Chinese ink and watercolour
Dimensions: 28 x 76 cm

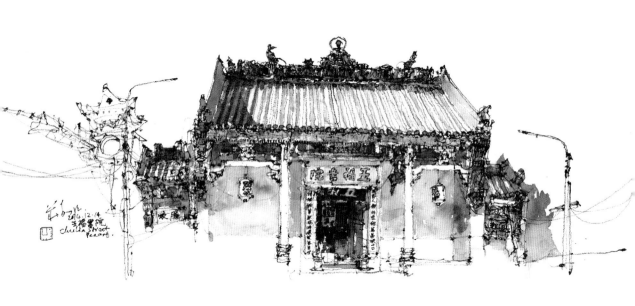

五福書院
Chulia Street
Penang.

31

Trusting our instincts

Marina Grechanik

One of the great characteristics of pen and ink is how the movement and energy of groups of people can be brought to the page in just a few swift marks. Marina's work as an illustrator and graphic designer means much of her time is spent working at a screen, but in drawings such as this, of people socialising in a bar in Jaffa, Israel, one can sense the immense enjoyment she gets from making images by hand on location.

Her lines make a virtue of working at speed: the constantly changing nature of the scene demands that postures and facial characteristics are shown by just a few expressive lines. Hair is shown by curling swirls, and distant figures by just a few gestural marks.

Preparing for such a drawing by making preliminary pencil outlines to work over in ink simply isn't an option; this may be an intimidating prospect for those new to working with a medium as unmovable as ink, but it encourages us to trust our instincts and enjoy the fluidity of the enquiring line. The energy comes from the immediacy.

BAR AT THE FLEAMARKET
Medium: fountain pen and waterproof ink
Dimensions: 23 x 30 cm

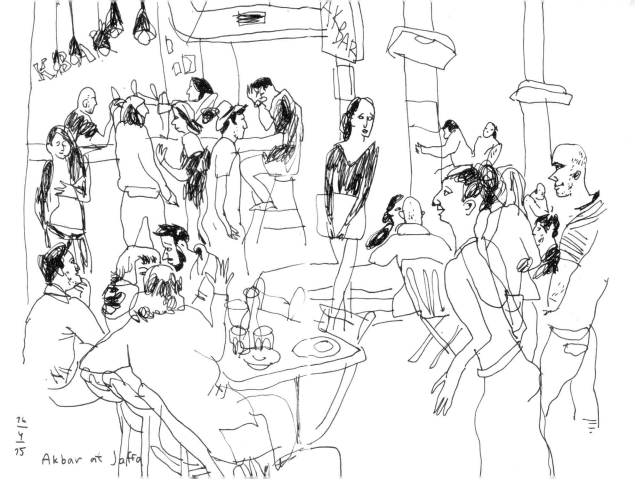

76
4
75

Akbar at Jaffa

Making every mark count

Òscar Julve

There is a beautiful economy of line in this drawing of a packed *xiringuito*, or beach bar, on the Barcelona shoreline. Our eyes are immediately drawn to the foreground where a busy confusion of diners sit on a shaded terrace. It is the liveliness of the line that suggests crowded tables and a hubbub of conversation: the drinkers themselves are shown with a few quick lines and little detail. In the area around the bar, people play on the beach and sail boats circle to add to the relaxed atmosphere.

The blue washes have a big effect on this drawing. The strong contrast between the foreground shadows around the tables and the untouched areas representing the ocean – not one mark is used to represent the surface of the water – highlight the Mediterranean quality of light.

The sky is shown as diluted, watery washes of blue, in front of which the dark shapes of buildings on the city's Olympic marina stand out. As a result, the beach bar is thrown into focus. In this drawing – on the distinctive ivory-coloured pages of a Moleskine sketchbook – every line and every wash is made to count, and not a drop of ink is wasted.

XIRINGUITO AT THE BOGATELL BEACH
Medium: fountain pen and wash
Dimensions: 20 x 25 cm

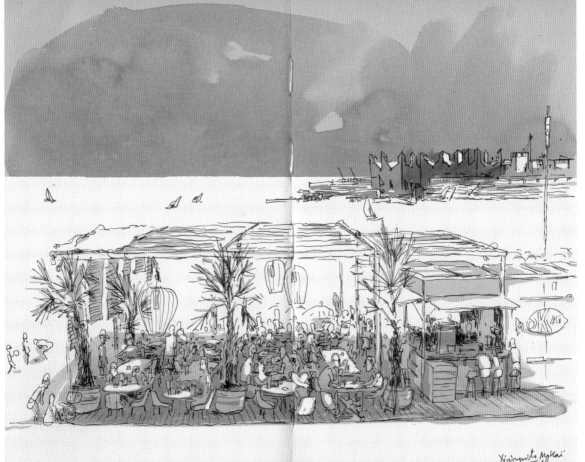

Xiringuito Mykai
al Bogatell

Blind contour drawing

Mike Slaton

Two figures sit at a table in an Indian restaurant, while from across the room they are drawn in free-flowing, energetic marks. The drawing seems to have captured a moment, one man lifting a glass to his lips, the other contentedly leaning over his meal. It is a refreshingly unrestrained drawing that emerges from marks that describe without copying, and so captures an event in the artist's personal way.

Some of the energy comes from the way the scene was drawn: by looking at the subject rather than the paper as the marks went down. Drawing becomes a continuous process, the pen always leaving a line, uninterrupted by stopping to look. The line itself leaves the paper, but by focusing on looking, the relationship between hand and eye is strengthened.

'Blind contours are beautiful because they are an artist feeling around a subject emotionally. It makes people pause,' Mike says. 'Attempting to depict a person or group's likeness and attitude is such a good way to interact with people.'

INDIAN RESTAURANT
Medium: lightfast pigment pen
Dimensions: 22 x 28 cm

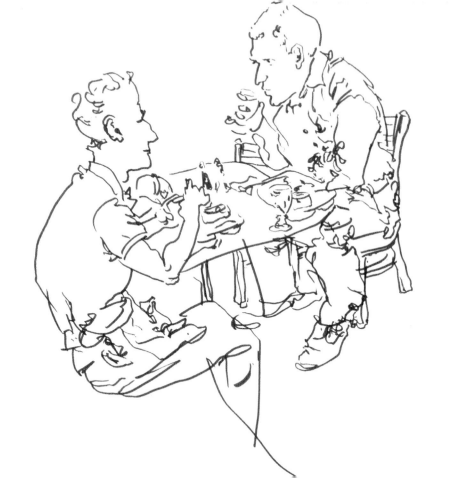

Choose a point of focus

Amer Ismail

Amer's drawing of the Reichstag, the home of Germany's Bundestag parliament in Berlin, shows it in isolation, with a total focus on the restored building's façade. There is no foreground or sign of what may otherwise surround it and hence put it into context, nor any sign of human activity around it. It is shown as a composition of strong vertical and horizontal lines with a perspective that suggests its vast scale.

So it comes as a surprise to hear it was drawn on the eve of Amer's first marathon among a crowd of runners familiarising themselves with the location. His background in architecture may be a reason for his total focus on the building before him. He turned to using fine pigment liner pens while working at the architectural practice Foster + Partners, the firm that designed the distinctive cupola on the restored Reichstag.

'When you work for such an important architect,' Amer says, 'you learn the way they do and design things – Norman Foster's sketches were done with fine pigment liners – and this trickled down to the way I sketch. I like the pen's simple, cartoon-like lines. And I was amazed that simple, quick and clean lines are good enough to convey information to clients during meetings and presentations.'

BERLIN REICHSTAG
Medium: pigment liner pen
Dimensions: 20 x 28 cm

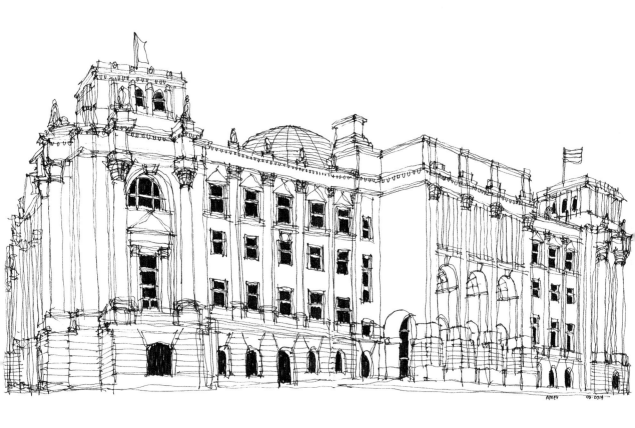

Exploring our surroundings

Mike Slaton

Keeping a pen and paper at hand at all times: it's the way to make our drawn responses to our immediate environment most enquiring. It is impossible to draw everything, of course, but having materials ready for when the time and place are right opens up new routes.

Mike was at the cinema, and he had with him, as he often does, his clipboard with printer paper (which he uses because it is always easy to find) and a ballpoint pen. After a while he realised that the audience's composition was more interesting to him than the film. The marks, made without looking at the paper as he drew, are loose and suggestive of the darkness they were sitting in, as if slowly making out the shape and form of things as eyes become accustomed to the light.

'When I draw, it's very personal and I am thinking about the world and how everything relates to everything else,' Mike says. 'Structures, identities, relationships, skillsets; all these things that I'm continually trying to understand better so that I can cope mindfully with the world.'

MOVIE NIGHT
Medium: ballpoint pen
Dimensions: 22 x 28 cm

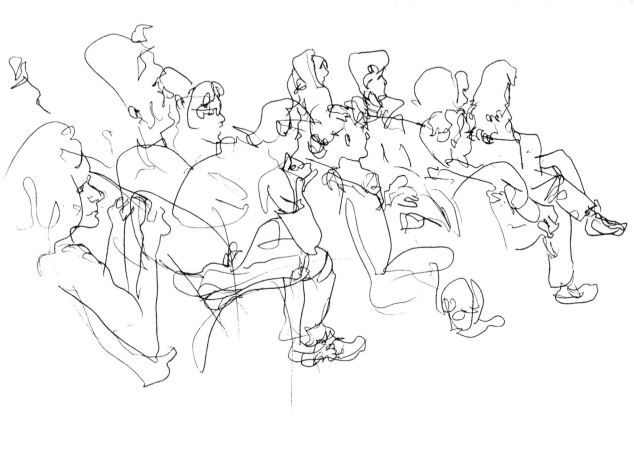

White ink on black

Phoebe Atkey

It was the view from the top of the Empire State Building in New York – and the photograph that she saved onto her smartphone – that led Phoebe to draw this scene of the towers of Manhattan.

Drawing from such a height simplifies elements of the scene in some ways – the movement and frenetic imagery of the city is so far below it is invisible, so the subject is essentially stationary – but the scope of the view is so vast it can seem a witheringly overpowering subject. 'I have tried to capture the chaos and simplicity of New York City, but also its structural symmetry, the beauty of its parks, architecture and shadowy secrets,' Phoebe says.

Her interest in drawing the scene white-on-black sprang from an interest in how that photograph may look as a negative. 'I think the white pen on black paper works particularly well with cityscapes, perhaps because there is a lot of pen work involved. It somehow changes the perspective, while still creating depth. I have found that in order for it to work I don't need to add in shadows or colour. Experimenting is always a good thing, even if it fails, because you can always learn something from it.'

NEW YORK: (WALKING THROUGH THE) SLEEPY CITY
Medium: white gel pen on black paper
Dimensions: 25 x 36 cm

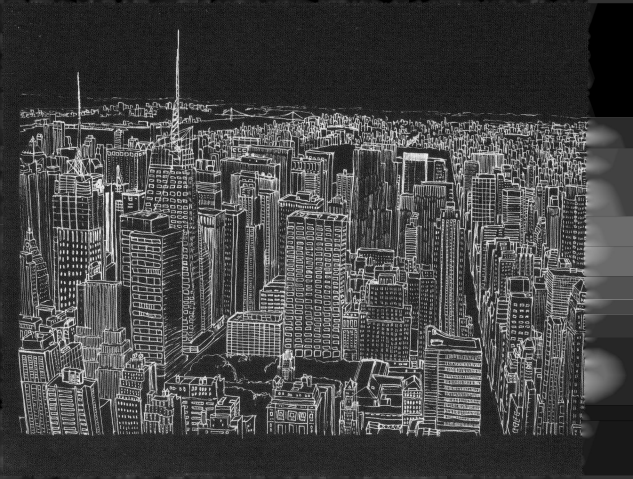

Drawing white space

Swasky

The simplicity of line and the balance between ink and white space make this a stylishly sparse drawing. Using a fountain pen with a fude nib, there is a great variety of expressive line, from the sweep of the young woman's hair to the curves of the mirror behind.

The reflection in the mirror, drawn with a grey felt-tip pen to give it less emphasis and a greater depth, gives the scene a whole new dimension and depth by showing the profile of the artist's wife by the café's windows, and, easily overlooked at the bottom, the hair and eyes of Swasky as he draws. The mirror frame becomes a picture within a picture, its ornate outline and the decorative lampshade hinting at the style of the interior without recording it in great detail.

The use of white space enhances the effect: untouched parts of the paper become as vital to the composition as the lines themselves, emphasising faces and profiles. The lines define the white spaces as much as describing the shapes of the subjects. This is a great example of how less can mean more.

CAFÉ CASA LIS
Medium: fountain pen and grey felt-tip pen
Dimensions: 18 x 23 cm

El café de Lis

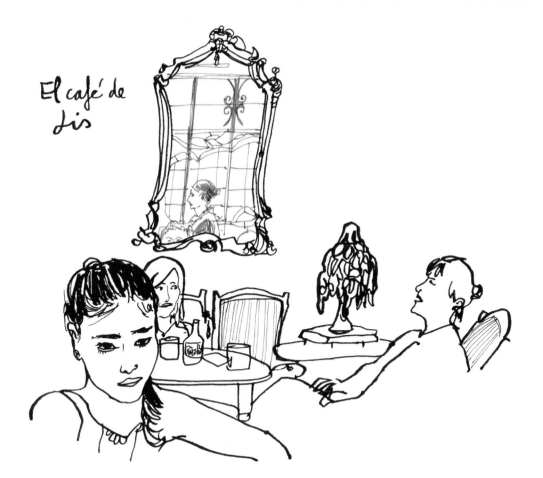

Leading the eye

Caroline Didou

Though the palette has been limited in a stark manner in this image, there is still a wide tonal variety across the paper and contrasts that entertain the eye and lead it around the surface. The foliage on the right, which has been gesturally applied with a blue permanent marker pen, is balanced against the fine, regimented lines of the architecture on the left.

While the depth of the buildings is suggested by the classical realm of perspective for artists, receding lines heading to a supposed vanishing point, the physical form of the tree is shown as a thick mass of leaves and branches through overlaid marks that range from tiny black pen lines to heavier stabs of blue marker.

Even the cobbled road, which gradually turns from the well-defined lines of stonework in the foreground to looser dashes and dots further back, and the van, pointing down the road, lead our eyes to the horizon, which has been abruptly interrupted by a construction crane. The overall effect of the drawing, which took Caroline about an hour to complete, is of precision and yet looseness, a simple and direct approach to an everyday scene that encapsulates the imaginative and technical scope of pen and ink.

RUE DE MONTFORT, RENNES
Medium: blue, black and grey permanent marker pens
Dimensions: 30 x 30 cm

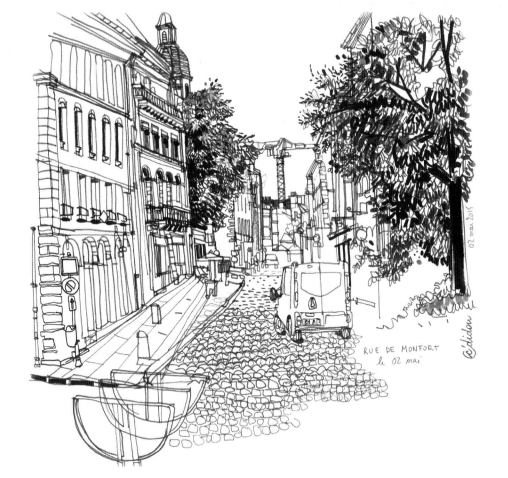

02 mai 2015

RUE DE MONFORT
le 02 mai

@didou

47

Making time count

Swasky

A ticking clock can have a big effect on the way a drawing is approached. The Plaza Mayor in Salamanca is a focal point of the Spanish city, ringed with restaurants and shops, and a popular meeting place. And with just a few hours left to spend in the city, Swasky knew his drawing would have to be a quick one. The plaza is famed for its intricate baroque architecture. As Swasky says, 'There are so many details you could spend your whole life drawing each of them.'

The lines are loose and immediate, and while in the search for speed they may overlook many of the finer points of the plaza's splendour, they do reflect its grandeur with the quickest and most telling of lines. The dining tables are shown by the curve of the chairs' backs, and there is the hint of activity under the arches in the background through the squiggles of barely defined heads.

However, by showing the plaza through the two foreground arches with their hanging lanterns, the scene is set for the magnificence of the balcony-lined buildings. It is a drawing that proves that time need not be a barrier to capturing the spirit of a place when using pen and ink.

PLAZA MAYOR DE SALAMANCA
Medium: fountain pen and ink
Dimensions: 15 x 27 cm

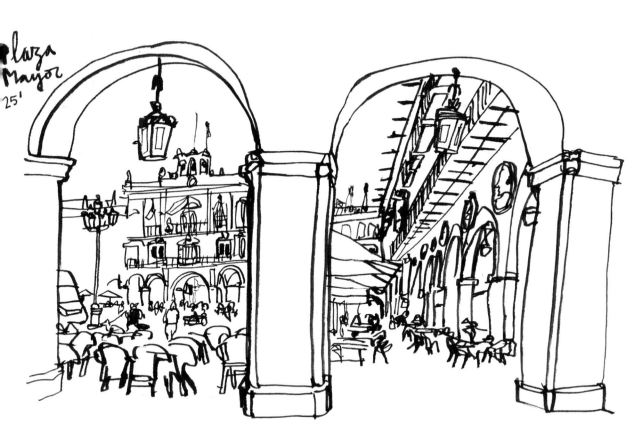

Plaza
Mayor
'25'

49

A balance of black and white

Rohan Eason

A commission to illustrate a story about the longevity of a yew tree, this picture draws out the tale's themes by emphasising the subject's human aspects – its limb-like branches, its aged demeanor, even its heart. 'I stood it alone and in darkness to symbolise the passing of time, as though it were a fixed point in an ever-changing landscape. Everything else disappears but the tree remains,' Rohan says.

Choosing from a series of sketches that aimed to find a balance between black and white, Rohan lightly transferred the outlines to hot press paper using a 0.1 mm pen and a light box, before removing the paper to complete the inking process with pens measuring between 0.1 and 0.35 mm. 'Because black and white work doesn't allow for light and shade, this must be expressed in concentration of line,' he says, 'so while you are describing form, direction, shape and distance, you are also describing pattern and texture.'

It is important to do as little on the light box as possible, because it can restrict the freedom and skill of the hand, and the final piece can become static and stilted. Even the background, a simple black, is completed with a 0.3 mm pen so that flecks of light show through, rather than being painted with a brush.

THE YEW TREE
Medium: technical pens
Dimensions: 20 x 18 cm

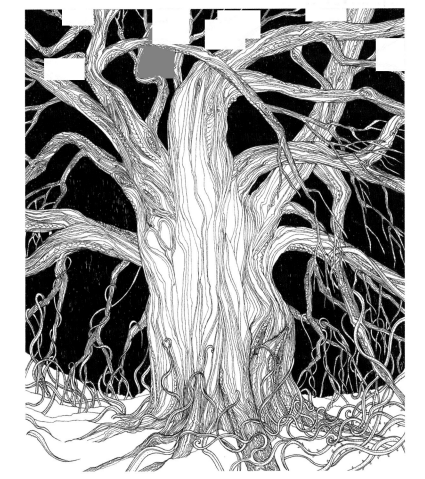

The uniform line

Cachetejack

This drawing is all about line, in a pure, bold form. It is a balance between the vertical lines that predominate in the upper half of the scene, and the horizontal lines at the bottom. The empty armchair is a classic device to make us, the viewers, imagine ourselves as part of the scene: we envisage ourselves slipping into it – once we have moved the reading glasses from the cushion.

The drawing was part of a series created for a zine, published by the artist duo Cachetejack, which explored the surroundings of different personalities from contemporary life. The simple black lines, relentless in their width and without subtle midtones or colours,

reproduce clearly and economically. The marker pen lines are a constant, broad weight, a quality that may seem a disadvantage in some circumstances, but here brings a boldness and visual energy that echoes the style of cartoons. We look at this drawing almost expecting to find an element of humour.

The directness of the line, which strips the subjects down to their bare essentials, is reflected in the approach to perspective: only the armchair and tables suggest any element of depth. It is a drawing that has tumbled from lively imaginations rather than careful observation.

AMBITIOUS VANITAS
Medium: marker pen
Dimensions: 13 x 13 cm

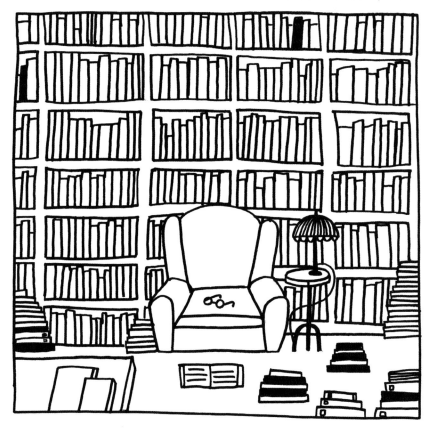

AMBITIOUS VANITAS

Taking a new view

Fred Lynch

To the dramatically sited hill city of Orvieto, Italy, this gentle, rural scene stares back from a distance. It is the kind of view that Fred usually avoids for being a cliché, overdone or so beautiful it doesn't need him to draw it. But for the sake of variety, from the edge of the city, he did draw it.

The change from his architecturally themed drawings, usually placed in the middle distance, inevitably resulted in a looser approach; the distance from the woods and fields across the valley meant details were less easily picked out. And the rural nature of the view encouraged a softer response; roads curve through the trees, hedges hug the line of the undulating landscape, and there are very few straight lines.

Even the edges of the image take on an organic element. 'Knowing where to stop a drawing can be tricky,' Fred says. 'The landscape was beautiful far beyond this drawing, but I elected to show less of it and to form a vignette – an irregularly shaped border. I chose natural boundaries to form the loose border of my drawing, rather than going to the edge of the page.'

OVERLOOKING ORVIETO
Medium: ink wash
Dimensions: 18 x 25 cm

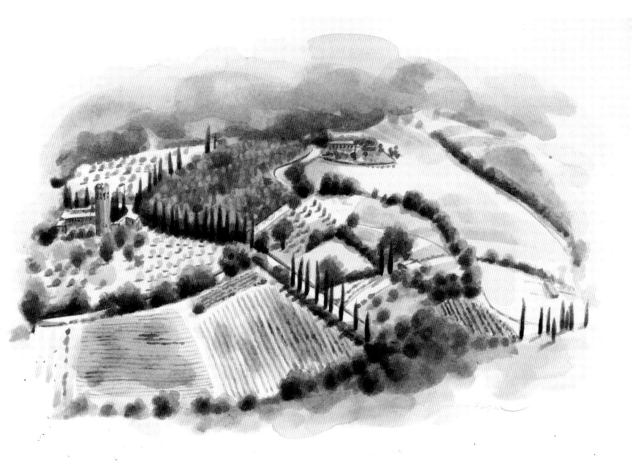

Responding to old masters

Michelle Cioccoloni

Michelle travelled to Madrid in 2014 to become the Prado Museum's artist in residence, giving her the opportunity to study the works of the old masters it contains. She made many studies of the paintings there and of Diego Velázquez's work in particular, experiencing first hand and close up his extraordinary ability to conjure up the presence of his subjects, giving a sense of space and air with the minimal amount of paint.

Responding to his approach, Michelle's delicate accumulation of marks slowly release the forms of these vine tomatoes from the page, weaving the image together to give a feeling of weight to the subjects and the space around them.

The drawing in lightfast ink is devoid of any lines or any discernible gestural marks: the subtle shift of tones across the heavy, handmade watercolour paper show the reflection on the tomatoes of the surface they sit on, while the background allows their forms to stand out in a sculptural way. But for all of the drawing's stillness, the surface is very much alive. It is almost as if the image is appearing from the page like a photograph appears in a dark room from developing fluid.

TOMATOES
Medium: pen and ink
Dimensions: 13 x 20 cm

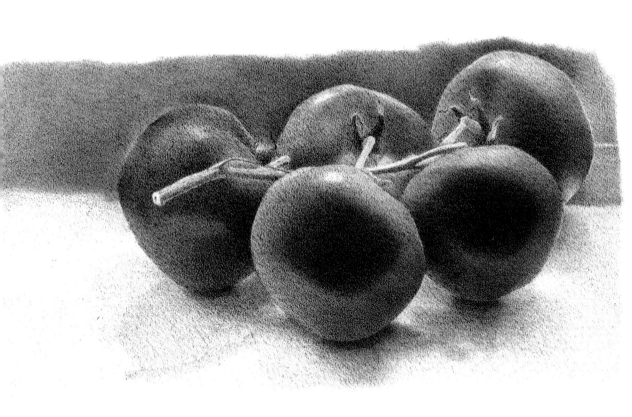

Exploring pictorial space

Dalit Leon

Dalit's process in creating this work from her series of untitled pen and ink images that explore pictorial space involved starting with layers of very diluted India ink washes in a wet-on-wet technique on heavy cartridge paper to create a bleeding, capillary effect. 'There is a significant amount of control even in this technique,' she says, 'because the ink applied to a wet surface that isn't immediately absorbed can be moved and shaped in a variety of ways, perhaps with a brush or absorbent cloth.'

Because layers of ink can take some time to dry, Dalit will have several works on the go at any time. 'I like the in-betweenness of drawing and painting, the fluidity of India ink and being able to use both brush and pen, its intensity when used undiluted and its behaviour and various responses to different processes.'

Sometimes it is obvious when such a work is finished, but this one required time. 'I had to stop and look at it over a period of days and weeks in order to decide whether more work was needed. In the end I sensed that although there is room for more articulation and a wider spectrum of tones, the drawing is complete.'

**UNTITLED
(PEN AND INK 40)**
Medium: pen and India ink wash
Dimensions: 22 x 15 cm

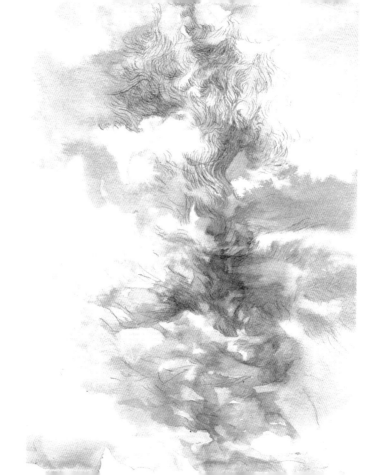

Experiment with cross-hatching

Amer Ismail

Jaisalmer is an ancient fortress city in the middle of the Thar Desert in Rajasthan, India, near the border with Pakistan. Wandering through its alleyways with his camera, Amer came across this nineteenth-century mansion, with an intricate sandstone construction.

Working from a photograph later, Amer first explored different weights of line and the extreme perspective presented by such a low viewpoint on a separate sheet of paper, before developing his approach on a second sheet. The shadows became an array of cross-hatched shapes pieced together that were worked up section by section across the drawing, with final adjustments made to ensure its light and tones were consistent across the paper. Working with tone by cross-hatching, particularly in larger works, can mean time-consuming and painstaking work in comparison with, for instance, ink washes applied with a brush. 'I found it strenuous for my eyes, and so taking breaks was essential,' Amer says.

The drawing is, essentially, an exploration of line and shading through cross-hatching, which is a change from his usual approach. 'I wanted to explore perspectives in drawing. I normally do standard architectural views so it was good to do something different and more challenging.'

JAISALMER, INDIA
Medium: pigment liner pen
Dimensions: 15 x 23 cm

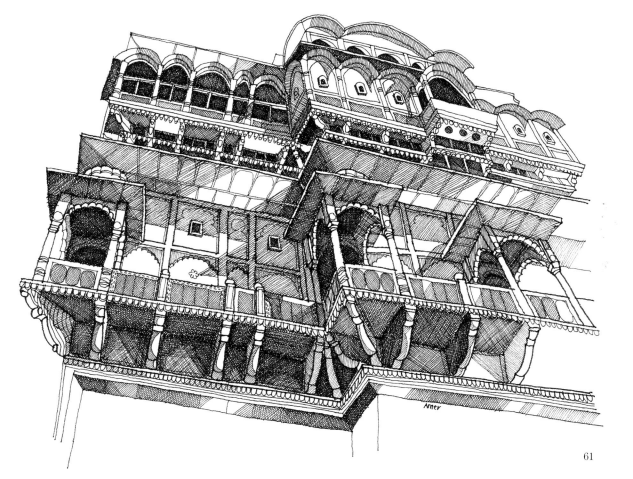

Amer

When pens run out

Fraser Scarfe

For this drawing, started on location in woodland and later completed in the studio, Fraser used a variety of sizes of marker pens. A disadvantage of such pens is that from their outward appearance it is not apparent how much life they may still have within them. They are unlike pencils, where what you see is, quite literally, what you get. (One of the advantages of fountain pens and dip pens is that they are refillable, as are some ranges of marker pens, resulting in less waste.)

Fraser uses the dropping ink levels in his pens to his advantage. As the pens begin to lose ink he labels them according to their tone, thus avoiding the need to scrabble through identical pens in the search for the one that is just right, or the temptation to jettison those that are past their so-called best. 'This way I can have a full tonal range at my disposal by using old pens, reserving the newest pens for the darkest blacks,' he says.

The areas of different greys from half-depleted pens used for this scene of a route through the undergrowth add another dimension as an intermediate tone, giving the effect of making the black areas even darker, and the untouched paper even whiter.

STAPLEFORD WOODS
Medium: waterproof ink
marker pens
Dimensions: 60 x 84 cm

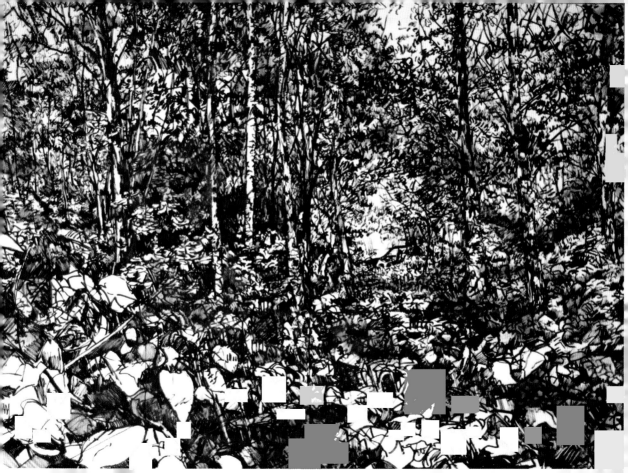

Shading with cross-hatching

Michael Lukyniuk

Michael lives in Canada and regularly heads out on Ottawa-Gatineau's many cycle paths to exercise and find places to draw in its urban landscape. Bicycles can be the perfect means of transport for location artists exploring an area: you are close to your subjects, can cover the ground quickly and it's easy to stop and draw when the right subject presents itself – although Michael's subject here is the bicycle itself.

He used a refillable technical pen with compatible black India ink for this drawing of his bike, which he began on location and completed from photographs. 'The ink is intense, and the 0.35 pen produces a nice, smooth line,' he says. 'The sketch was done purposefully to see what effect simple lines could produce for shading.'

The hatching he has employed works together with the linear outlines of the bicycle and railings to create a range of tones, from the lightness of the foreground shadows to the dark black of the bike's tires. The tones, which enhance the subject's sense of form and volume, can be varied through the density of the lines and the size of the nib, while cross-hatching – in which lines are laid over each other in two or more different directions – can produce the densest blacks.

THE BICYCLE
Medium: technical pen
with black India ink
Dimensions: 20 x 25 cm

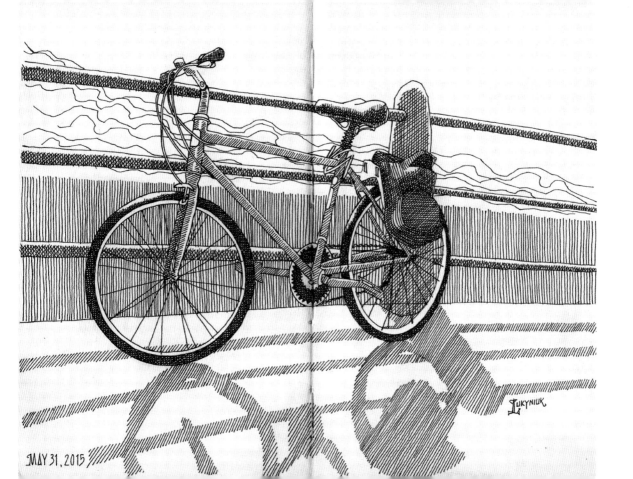

MAY 31, 2015

LUKYNIUK

Building tonal washes

James Hobbs

One of the exciting qualities of India ink is the way in which, because of its waterproof nature, it will (when dry) remain in place when other layers or washes are painted on top. There are times when its permanence and immovability can seem a disadvantage, but it has its positive aspects that can be used to creative effect. For instance, when washes of India ink that have been diluted are applied in coats, each layer darkens the tone of those beneath it, doubling it up. It can be worth having more than one drawing on the go at one time, depending upon the drying conditions: work on one while the other dries.

In this drawing the foliage of the trees and the spire have been built up with washes of diluted ink. While working in this way can be a slow, meditative process that can be planned, it is possible to overstep tonally: there is no going back to a lighter tone once an area has become too dark. Touches of green ink, and a number of lines using a black marker pen, have also been used to create a variety of marks and textures.

PARK
Medium: India ink and marker pen
Dimensions: 13 x 18 cm

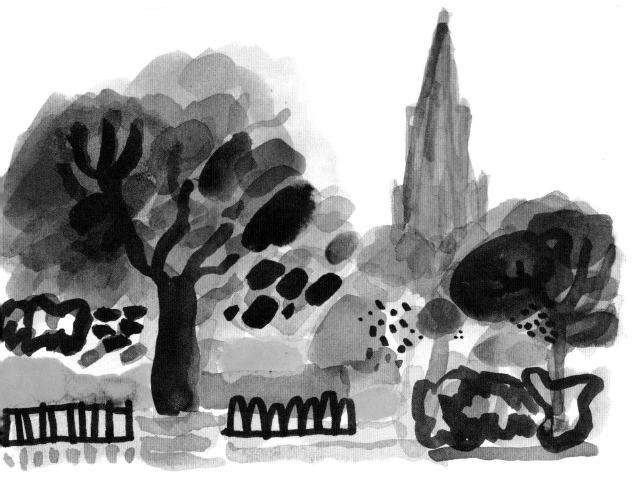

A sense of energy

Ch'ng Kiah Kiean

The exuberance of this drawing of a street in George Town, Malaysia, comes across immediately in the way its subjects merge and blend, and the trail of drips and splashes around its periphery that give the impression it has been painted very quickly. It is a drawing that rewards close attention. Things emerge as we look and explore: people, vehicles, posters and more take shape.

The central tree is a dominating presence, with intense black foliage that spreads and casts its shadow around the buildings. The street is in the city's heritage zone, and known as Little India because of its Indian community; for all of the drawing's looseness and energy, it is important that this distinctive character of the area is shown in the finished work.

On either side of the image, the softly drawn Chinese ink lines from sharpened dry twigs have been used by Kiah Kiean to represent lampposts as a kind of frame to the central activity of the composition. He puts gauze in a small bottle of ink to prevent the twigs from becoming too wet and hard to control when they are dipped in. The marks here are soft and natural, and a contrast to the areas of intense black.

PENANG STREET
Medium: dry twigs and Chinese ink
Dimensions: 28 x 76 cm

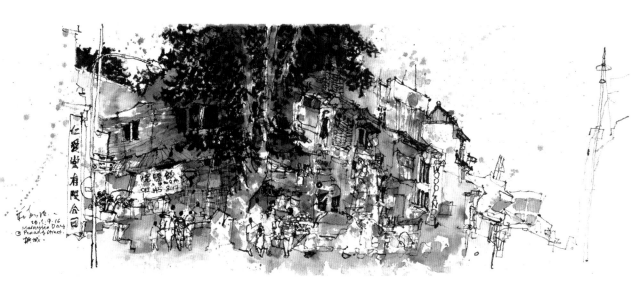

69

Photographic references

Mike Slaton

Mike's college assignment was to illustrate a character from a book by a list of authors; in his research to draw Estella from *Great Expectations* by Charles Dickens he took reference photographs to work from, paying particular attention to having good, considered light sources. Along with a variety of fineliners and brush pens, he also used a stamper's white pen to go over the dark areas to lighten and blend.

This image shows the initial drawing, which Mike later finished digitally on his iPad. His attention to detail on light sources is apparent – the way the light falls across the sitter's hair and face is at the heart of the drawing. Shadows are intense areas of black ink, while her forehead and the top of her head remain untouched white paper.

For illustrators just starting their careers, the digital route is one that sits alongside traditional methods. 'I really like working with ink,' Mike says. 'The more comfortable I am with traditional media, the better my skills should be when transferring to painting or drawing with an iPad.'

ESTELLA FROM GREAT EXPECTATIONS
Medium: fineliners and brush pens
Dimensions: 22 x 28 cm

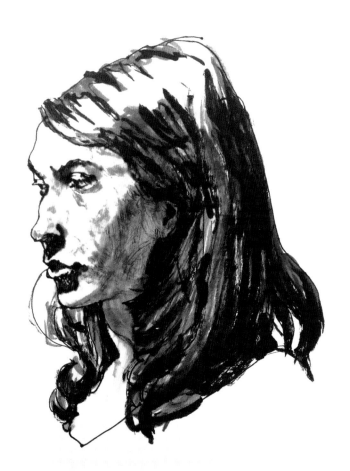

Capturing the ongoing moment

Michelle Cioccoloni

What is arresting about this drawing of a Scottish rural landscape at dawn is the way Michelle has taken an apparently simple scene and captured on location a period of shifting light with her approach of building a surface through a succession of hatched ink marks. The foreground area of pasture in shadow takes up more than half of the image, and is shown as a shape that may be difficult at first to read.

'The drawing started with two grey shapes: the foreground and the distant trees on the horizon,' Michelle says. 'As the sun became stronger, it brought definition and contrast to the shapes on the horizon. There are extremely subtle variations in the grey tones to indicate the trees. The soft tones also give the illusion of the sunlight shining on them.'

A focus on light in a drawing doesn't mean that it has to be completed within minutes. 'The moment in *Dawn* lasts longer than a fleeting moment,' Michelle says. 'Watching the sun rise, the forms of the landscape slowly emerge over a period of two hours and the drawing develops with the rising sun, an 'ongoing moment', as the writer Geoff Dyer calls it.'

DAWN
Medium: pen and ink
Dimensions: 9 x 15 cm

Going large

Patrick Vale

This is a big drawing, measuring five feet high, but it started out as a small drawing in a sketchbook. Armed with the drawing and a series of stitched-together photographs of the view across San Francisco, Patrick set about this larger version in his studio in preparation for an exhibition of his work. It doesn't depict the actual scene, but he has forced the perspective to the extent that he can create the composition that will work best. He used 0.3 mm technical pens – going through about 20 of them – for the initial line drawing, which means he has been able to include a huge amount of detail.

The lines running across the telegraph poles form a latticework above the street. Layer upon layer of washes of diluted India ink were then added on top of each other to gradually build the range of greys that represent the shadows. Areas of white applied in places with correction fluid, such as on the telegraph wires and as reflections on the parked cars, bring back white highlights.

'What I like about pen and ink is that you have to commit yourself to the line straight away,' Patrick says. 'There's no going back. It's about being confident and expressive. I like the danger of that.'

COIT TOWER, SAN FRANCISCO
Medium: India ink, technical pens, correction fluid
Dimensions: 150 x 250 cm

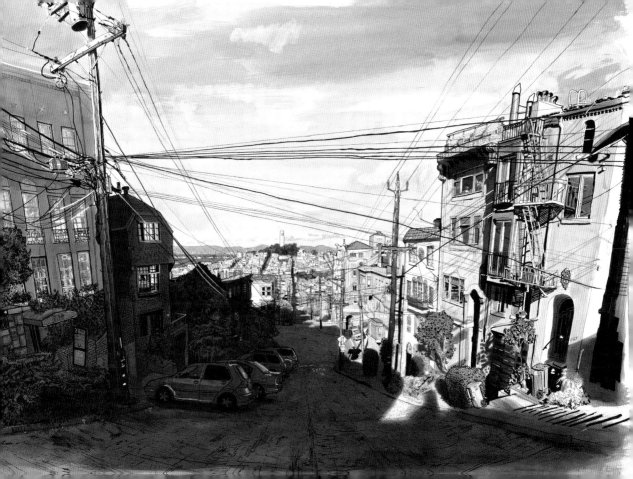

Contrasting patterns

Cynthia Barlow Marrs

Airports are a common place to draw in: they often provide a kind of dead time in waiting areas for delayed flights that a sketchbook and pen can make worthwhile. Cynthia's eye was caught by the contrast in patterns between the woman's jacket and the handbag resting on her knee as she waited for a flight at Kansas City International Airport. The main subject is placed well off-centre to the right; the left hand side of the opened sketchbook contrasts the whiteness of the empty sky with the hatched darkness of the textured seating. The back edge of the seating echoes the line of the featureless horizon.

A black pigment pen has been used with a dual-ended wash pen with a brush at one end and a felt-tip at the other in a variety of greys. 'The pigment pen is permanent, but the dye-based wash pen is not, so I use it only in sketchbooks while travelling or in work destined for the scanner,' Cynthia says.

Cynthia started the drawing with a grey 'dark enough to suggest a bit of form, but light enough to keep my options open. If you are teaching yourself about tonal range, a set of grey pens is brilliant.'

GATE 76
Medium: black pigment liner pens and grey wash pens
Dimensions: 20 x 28 cm

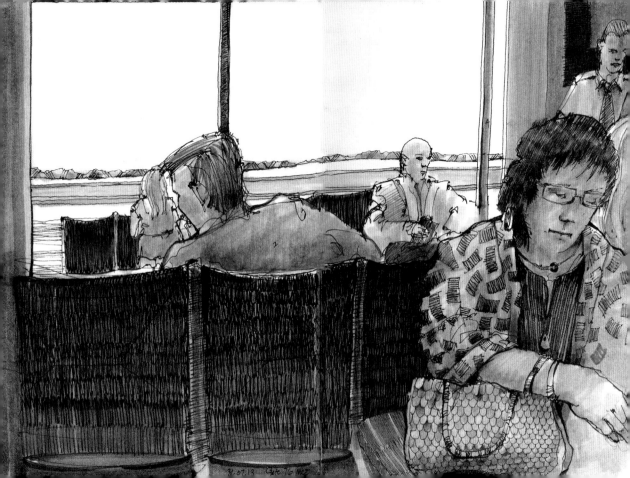

Make the work your own

Fred Lynch

Fred has two approaches to his subjects: self-given assignments; and serendipity – what he describes as 'a form of hunting'. This drawing was a case of the latter, a scene chanced upon in the mediaeval quarter of Viterbo, Italy, a town he visits each year with students and faculty from American colleges as part of a study abroad program.

Because light can change so rapidly, Fred applies a quick, light wash over a gestural pencil sketch, and takes a photograph for later reference. He works from the general to the specific, from light to dark, using 207 gsm hot press watercolour paper and brown ink. Although details come last, there is much left out. The building featured here was constructed entirely in stone, but he has chosen to describe only the largest of them, for instance.

'While I strive to capture the scene as I see it, to get it 'right', I'm not afraid to impose my personality on the works,' Fred says. 'I'm not interested in repeating what's before me as a photograph does, but rather to interpret the scene my way. My first lines are often wrong, and I like to keep them sometimes and build on them.'

MEDIAEVAL CONDOS
Medium: ink wash
Dimensions: 25 x 36 cm

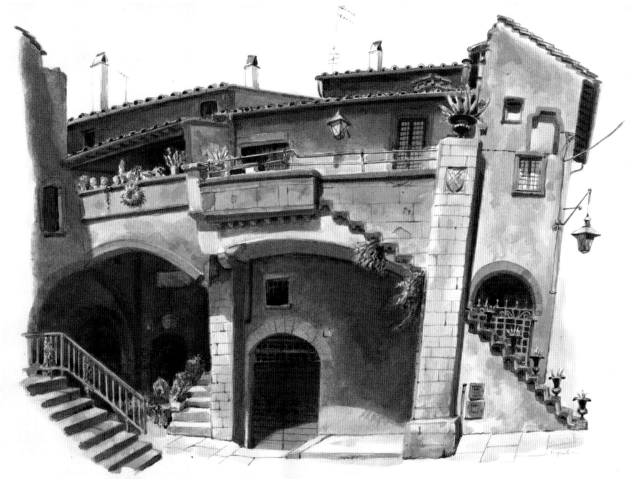

Shades of grey

James Hobbs

A well-stocked art materials shop will reveal ink pens in a bewilderingly huge range of sizes, nib shapes and ink types – it is worth taking a sketchbook to try some out to see which you like the feel of and which may suit your way of working. This drawing was completed with a handful of dual-tipped warm grey pens, a drop in the ocean of those available, but enough to bring another dimension to the monochrome image. It is a spontaneous drawing, done in a few minutes standing up on the street.

The thickness of the line is a bold statement, and there is no going back once it is on the page, but experience of using the same pen and nibs over time can reveal their secrets and the way that subtle varieties of line can be made. This may be accomplished by holding the pen at different angles or finding a point on the side of a bullet nib that can give a different quality of line.

The pen is an instrument, one from which we should aim to get a rich scale of notes. The better we know the implements we are drawing with, the more able and confident we become to coax from them nuanced and expressive marks.

ROSSIO SQUARE, LISBON
Medium: twin-tip marker pens
Dimensions: 15 x 20 cm

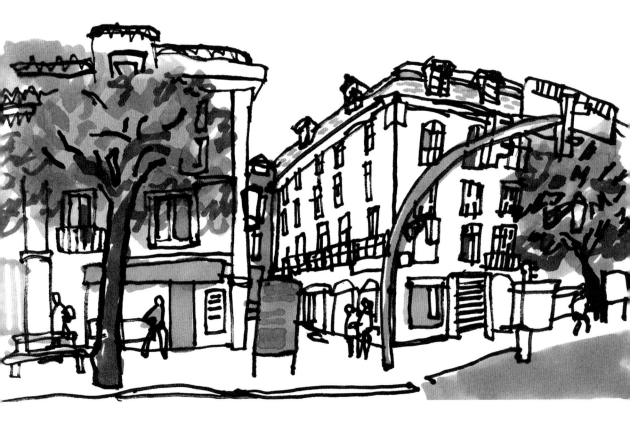

Preparing the ground

Mike Slaton

The freedom and energy of an image once it is seen online or in print can often give no hint of the careful preparation and editing that it has undergone. This section of a larger black and grey ink drawing, which was a portfolio piece for Mike's illustration coursework, was meticulously planned from a series of reference photographs that he had collaged together. He used a grid method (a grid drawn over the reference images that matches that on the drawing paper so each square can be individually duplicated) with a non-photo blue pencil, which remains invisible when it is scanned or photocopied.

Pigmented, lightfast drawing pens in black as well as warm and cool shades of grey were used to draw the stooping figure, with unwanted marks covered by correction tape, an opaque masking material stuck down onto the paper. Mike is always thinking of how his work will look online when it is finished. 'Getting a page, sheet, or canvas to look as good online as it looks in your hands is something to aim for,' he says. 'I scan my work with a scanner if one's available or a scanner app on my iPad. Any adjustments can be made digitally.'

FIGURE IN LAB
Medium: bullet-nib pens, non-photo blue pencil
Dimensions: 15 x 8 cm

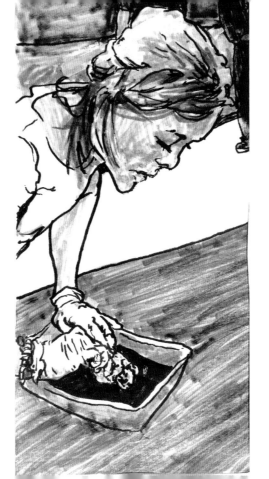

Painting a stage

Òscar Julve

This well-observed drawing of a petrol station in Barcelona, Spain, is given a great sense of scale by its placement in the lower part of the open sketchbook. It is as if the station's canopy is the proscenium arch surrounding the stage of a theatre, and the workshop's equipment is part of a stage set, although no actors are apparent. The fine lines of the fountain pen are ideal to show the pay booth, petrol pumps and assorted wall fittings.

What is not theatrical, however, is the lighting. Whereas we may expect a stage to be bathed in brilliant light, here the forecourt is picked out by a large dark blue wash, and yet our eyes are still pulled towards it. The washes of blue are beautifully loose, not clinging to the drawn lines, yet still describing the dark shadows cast by a bright Spanish sun.

Trees on either side of the scene give a balance. Because of the energetic way in which they have been rendered, the trees' species will never be identified, but that is beside the point: by being half obscured, they hint at more activity and points of interest down the roads to the left and right.

GAS STATION IN CARRER DE LLULL
Medium: fountain pen and wash
Dimensions: 20 x 25 cm

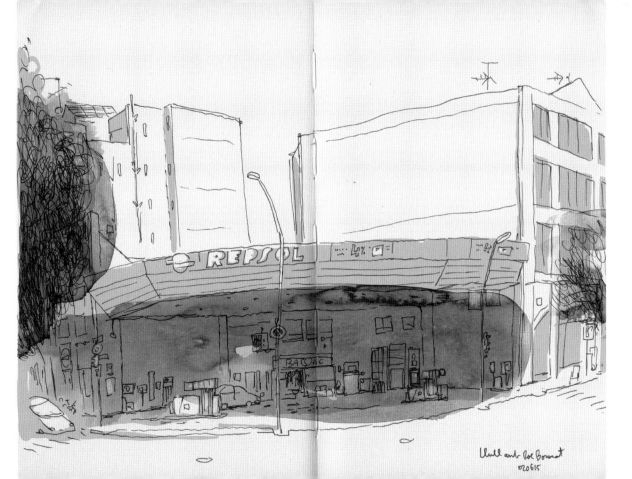

Llull amb Roc Boronat
020615

Simplicity of line

Sabine Israel

The simplicity of line is one of the most alluring qualities of pen and ink. The ink lines portraying these three oranges are minimal to the point that they are so bound up in the composition we are hardly aware that they are there. They are lines that started as a pencil drawing done from life, which were transferred by tracing them on a light table with a glass-nibbed pen and black carbon ink. The lines are a kind of anchor, holding fast to the shapes of the oranges and the tapering leaves, while the colour brings energy and expression to the illustration by spilling out beyond the confines of the outlines.

Sabine likes using glass nibs – they have curved grooves to hold the paint, and are fixed in a holder – because of their smoothness on the paper and the way the ink flows from them. The variety of line they can produce is noticeable in the curved lines of the leaves.

The colour elements in this work were made by rolling acrylic pigment over circular stencils to create shapes that were brought together with the ink drawing in Photoshop.

THREE ORANGES
Medium: glass-nibbed pen
and ink with acrylic
Dimensions: 20 x 30 cm

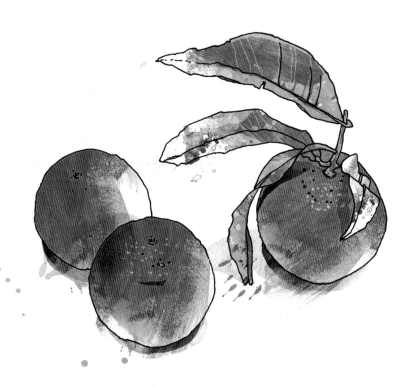

The element of chance

Wendy Winfield

There is always an element of chance when you are working outdoors, especially if you are on location where the weather can be changeable and conditions alter from minute to minute. Wendy's expressive approach on heavy watercolour paper drawn at the Greenwich Old Royal Naval College, London, embraces these uncertainties. 'The sky was exciting so I needed to add colour,' she says, 'and I often use ink to give instant strength. I draw it across the paper with a stiff hog hair brush and let it go where it will.'

The ink washes gather in the undulations of the cold press paper, reflecting the unsettled nature of the sky. Over these washes Wendy has used a bamboo pen and a fine, steel-nibbed dip pen for the architectural details and the suggestion of figures in the middle ground. (Smooth hot press paper may be the surface of choice for pen and ink artists aiming for fine detail, but personal preferences mean this need not be so.)

A touch of yellow picks out the weathervane on the domed tower. 'My work makes no claims to architectural accuracy,' Wendy says, 'but attempts to evoke its own sense of place and time.'

KING WILLIAM COURT, GREENWICH
Medium: pen and ink wash
Dimensions: 30 x 20 cm

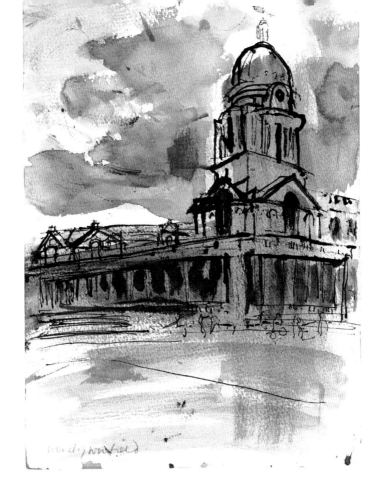

Try drawing with ballpoint pens

Marina Grechanik

Ballpoint pens are a surprisingly popular medium to draw with – Cy Twombly and Andy Warhol are among those artists who have used them – and for a variety of good reasons. Wherever we are, at home or in the workplace, if there is one kind of pen that is likely to be close at hand it is a standard ballpoint. They are cheap, they flow easily across the surface leaving (usually) a steady line and can be used on all kinds of paper. It's the pen most likely to be on sale in your nearest shop.

This drawing by Marina has been done with a single pen that contains a number of colours. Showing the bar of a busy restaurant and drawn across an open sketchbook, the pen captures the immediacy, liveliness and colour of the food preparation area as brunch is prepared. The emphasis is mainly on line, but colours can also be worked across each other in a more time-consuming cross-hatching process or, as here, with denser, looser, overlaid marks.

An important aspect of using a ballpoint pen for a drawing is that it will fade in time, particularly if it is exposed to light. If you want it to last, scan it, keep it in a sketchbook, or look for pens with archival inks.

IN CLARO AT THE BAR
Medium: ballpoint pen
Dimensions: 23 x 30 cm

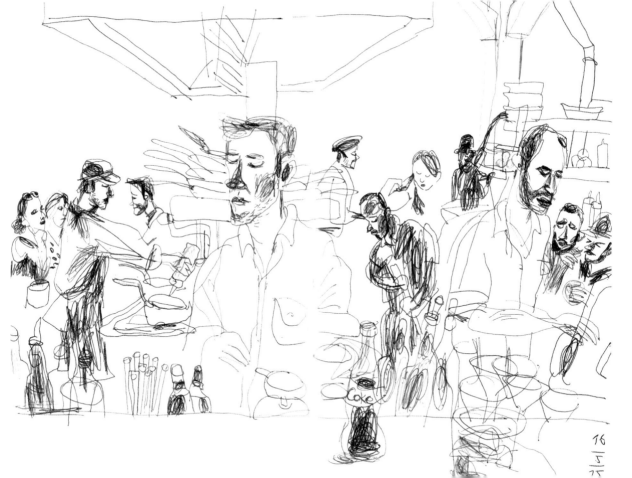

The personal approach

Chris Lee

If you give identical drawing equipment to two artists, you shouldn't expect them to deliver identical lines, just as you wouldn't expect two guitarists to sound the same playing similar guitars. Marks inevitably take on a personal nature. Chris used his favourite pen, a very fine 0.05 pigment liner, to draw this scene of Linz, Austria, as he leaned against a lamppost. 'It's ridiculously fine and rather too fragile for my large hands. I destroy two or three nibs per drawing,' he says, 'but the nib just dances across the paper so fluently, adding to my eccentric style.'

The city's towering cathedral stood close to this scene, but it was this concoction of colourful buildings that caught Chris's attention. The lines of the tram cables and road markings draw the eye in, and other road signs and street furniture are included. 'They make a scene live,' he says. 'They add visual punctuation to the shape of the drawing.'

Chris never works from photographs, and uses pen and ink without resorting to preliminary pencil outlines. 'The graphic shape of the drawing is crucial,' he says. 'I never fade out the edges. That is where the hedges, road markings or tramlines help to delineate the picture.'

LINZ, AUSTRIA
Medium: pigment pen
and watercolour
Dimensions: 20 x 28 cm

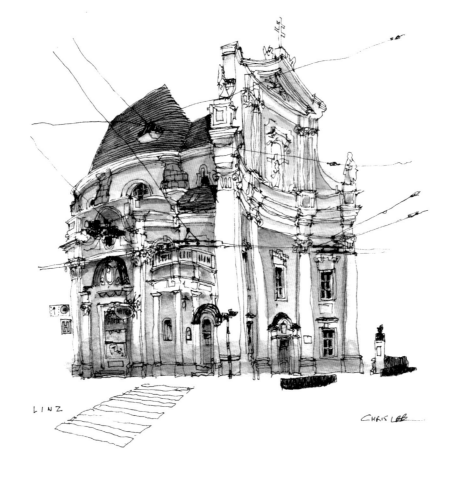

LINZ

CHRIS LEE

93

Ink's intense colour

Wendy Winfield

Wendy chanced upon this small beach during a visit to St Ives, Cornwall, a town that has long been an attraction for artists. She had already made half a dozen drawings of the rocks from the top of the low cliff when she clambered down to do this drawing in India ink. 'I had left my watercolour sketchbook at the top,' she says, 'so I did the drawing in ink and clambered back. By this time the sea was full of marvellous colours and the lichen was glowing, so I used coloured ink to express this sensation. It really was a sight to behold.'

The intensity of the black ink has the effect of enhancing the brightly coloured inks by standing out strongly against them. Acrylic inks are 'strong, quick, and extravagant', Wendy says, in comparison with watercolour.

It is a sketch that retains the energy and spontaneity of being drawn on location: 'My drawings are done on the spot, and I don't go home and do more work on them afterwards. I don't sharpen up lines or tidy things up later. They stand or fall as they are.'

PORTHGWIDDEN, CORNWALL
Medium: India ink and acrylic ink
Dimensions: 20 x 30 cm

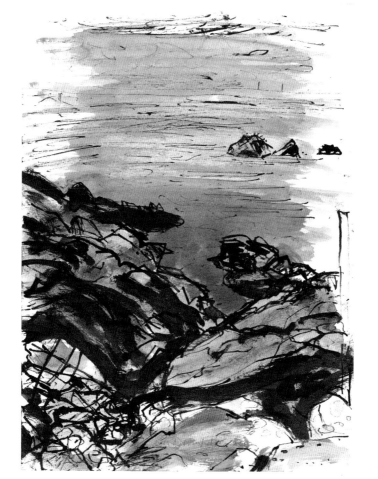

Find a focus

Susan Toplitz

There is something refreshingly direct about this drawing of a custom-made chopper. It is shown standing among a group of other custom motorcycles at a large gathering in a car park around a bar outside New York City where owners meet to show and discuss their bikes. Because the bikers meet in the evenings, Susan had to work fast before the light faded. 'I don't have time to fiddle with an eraser so I go in right with ink,' she says. 'I decide what my focus is and get right down to business. I try to include figures to tell a story, rather than it just be a motorcycle drawing.'

The chopper is the unmistakable focus of the picture; the bike's builder even advised Susan on the best view from which to draw his creation. The red bike and standing figure are part of a muted background, and portrayed without line work, but they are enough to suggest the context in which the bike was drawn. 'The bikers were more suspicious of me in the beginning,' Susan says, 'but now I am recognised as a regular at their meetings and they come over to see what I am drawing.'

BIG BLUE CUSTOM CHOPPER
Medium: ink with watercolour
Dimensions: 28 x 36 cm

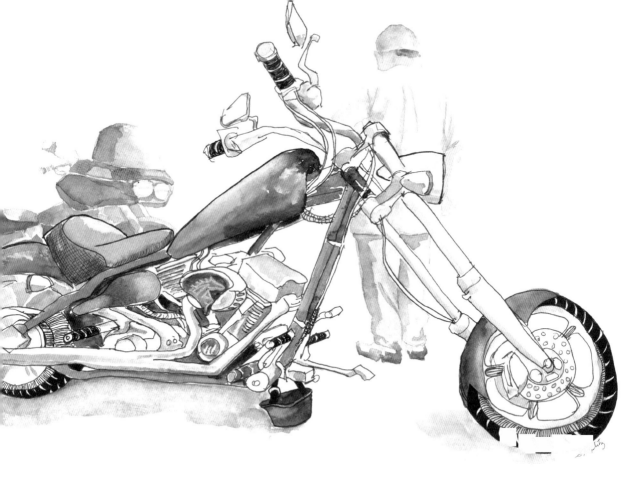

Cross-hatched colour

Fred Kennett

On first inspection, this image doesn't seem to be drawn solely with pens at all. It is big in scope, sensitive in colour and rich in detail. It is, in fact, a drawing that has been gradually built up with fine lines and cross-hatching using fine technical pens in a range of colours. Considering the size of pens that Fred used – they range from 0.13 to 0.5 mm – and the scale of the work – 56 by 79 cm – it is not surprising that it took a long time to complete. The drawing is part of a set of three that he worked on over a period of about a year.

Drawn over a rough pencil sketch, the colours were 'mixed' by bringing together and overlapping the lines and marks of different pens. For instance, Fred mixed the shades of brown by building a combination of yellow, red and blue pens, and then created a range of browns by using different shades of those three colours.

This subtle variation in mixing ensures that he never gets quite the same colour twice. In places, though, the paper is left untouched; the tree trunks are portrayed through negative space to show as a striking vertical rhythm across the top half of the paper.

WOODS 2
Medium: technical pens
Dimensions: 56 x 79 cm

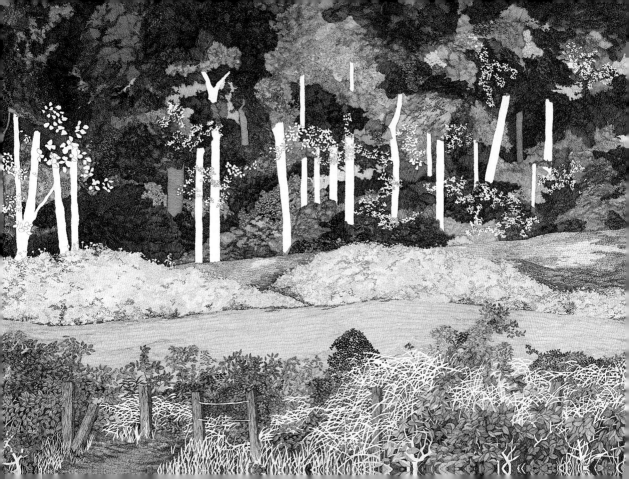

A focus on colour

Jedidiah Dore

Using pen and ink doesn't mean there is no room for colour. This drawing was done on location at an exhibition at the New York Botanical Garden that evoked the Mexican home of the artist Frida Kahlo. Even the house's name – Casa Azul, or Blue House – shows how central colour is to the building and its inspirational garden and why Jedidiah felt a colourful response to it was most appropriate.

This drawing features a scale version of the Casa Azul's stepped red, blue and yellow pyramid, which is used to display Mexican cacti and succulents. 'There is an intensity and emotion to Kahlo's work that I loved and wanted to pay tribute to,' Jedidiah says.

The drawing's groundwork is laid down by the use of a light, 118 gsm, coloured paper with sweeping washes of shellac-based coloured ink. When this had dried, the black, drawn shapes of the plants and foliage were added. 'The colours of Mexico and Frida Kahlo's art on exhibit are intense,' says Jedidiah, 'so I included a few areas of crayon to highlight that character.'

CASA AZUL AT NEW YORK BOTANICAL GARDEN
Medium: pen and ink wash, crayon
Dimensions: 30 x 46 cm

Inks for fountain pens

Joan Ramon Farré Burzuri

Drawing a well-known building, such as Joan Ramon has here of the Notre Dame cathedral in Paris, France, takes on certain aspects of portraiture: people will immediately decide whether the finished work has captured a likeness or not. The temptation can be to tighten up and become over-concerned with detail, but Joan has maintained a freshness and vibrancy in his flowing India ink lines on 300 gsm paper without compromising the scene's singular character.

Fountain pens should generally only be used with non-waterproof inks, but here Joan Ramon has used an Osmiroid fountain pen for drawing that is compatible with (waterproof) India ink. This has allowed him to finish the work later with the addition of watercolour over the rich black India lines done on location without disturbing or blurring them.

If you are drawing with a fountain pen – which is filled by drawing ink through the nib by suction, in contrast to dip pens, or nib pens – check that the ink you are using is suitable for it. Writing inks used in fountain pens tend to be water-based and therefore not waterproof. Fountain pens are fantastic and convenient implements to draw with, but using the wrong ink can cause the nib to clog or even become damaged.

NOTRE DAME, PARIS
Medium: pen and India ink
with watercolour
Dimensions: 21 x 29 cm

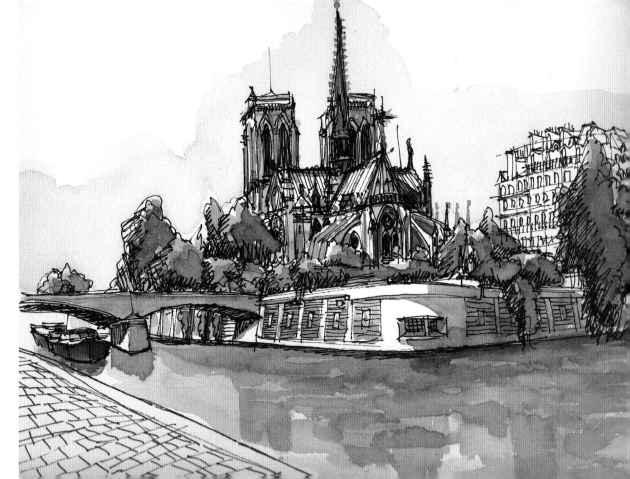

Take a chance with twigs

Marina Grechanik

There are times when a scene may suggest not just a particular way of portraying it, but the use of a specific drawing implement. The variety of line in this scene in central Tel Aviv, Israel, is down to the dry twigs used to apply the ink. Marina was taught to draw with twigs and Chinese ink by Ch'ng Kiah Kiean (see pages 30–31, 68–69, 134–135, 142–143, and 194–195), and she likes to use them when she thinks the less predictable marks that come from twigs suit the subject.

The quality of line – which can come as a surprise sometimes – is affected by such factors as how loaded with ink the twigs are, their size and even whether they are hardwood or softwood. They can, of course, be sharpened and shaped to produce finer points.

This variety has been brought together with colour and shapes and overlapping lines to capture the noise and movement of the busy square. The colours merge and blend with each other and the Chinese ink on the watercolour paper in a distinctly personal way: 'Colour is an integral part of building shape and form in my sketches,' Marina says.

MAGEN DAVID SQUARE
Medium: dry twigs and Chinese ink and watercolour
Dimensions: 24 x 30 cm

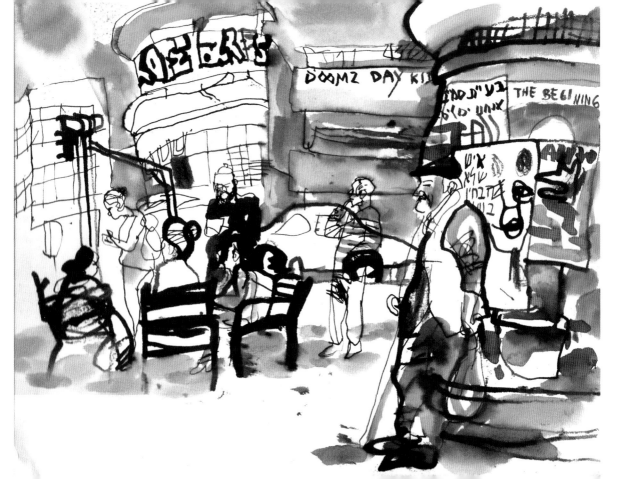

Focusing on a single object

Sabine Israel

Zooming in and focusing on a single subject can make for an arresting image; we get so close to this eye, for instance, we may feel we can almost see our reflection in it. For a single object to fill the paper, it has to be able to grab and hold our attention.

Two contrasting media come together for this image. The features of the eye were drawn in ink with a flexible, gold-nibbed fountain pen. (Flexibility in a nib allows it to broaden and then narrow in response to changing pressure as it moves across the paper, to give a variable quality of line.)

As a backdrop, a selection of colour washes in acrylic, ranging in intensity and overlapping in places, have been assembled in Photoshop in what might appear to be a random manner. Attention focuses instead at the very centre of the image, where the reflected light in the eye shines out.

EYE
Medium: fountain pen and ink with acrylic
Dimensions: 20 x 30 cm

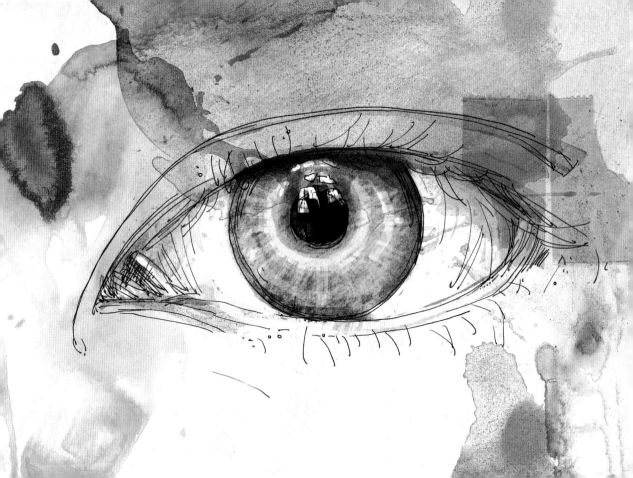

Using carbon inks

Joan Ramon Farré Burzuri

This sketchbook drawing of a street scene in Stockholm's Old Town district is distinctive in the way the upwards view overlooks the street-level activity to focus on the rooftops and sky. This has the effect of accentuating the narrowness of the cobbled streets, as the perspective suggests that the buildings are leaning together as they rise. The line work Joan Ramon has employed is relatively minimal in this drawing, allowing space for large areas of solid and splattered water-based colour, applied when the black ink has dried.

Joan Ramon used a fountain pen with a curved nib and the rich tones of black carbon ink for this drawing. Carbon ink consists of fine particles suspended in a binding agent, and as it is more fluid than India ink, he likes the way it allows him to work more quickly.

Although carbon inks tend to be water-resistant rather than waterproof, it is advisable to take the time to flush through and clean nibs regularly with warm water to prevent damage. Finding the right pens and right inks that suit the way you work is a very personal journey, and one that requires experimentation and time.

TRÄDGÅRDSGATAN, STOCKHOLM
Medium: fountain pen and carbon ink with watercolour
Dimensions: 13 x 21 cm

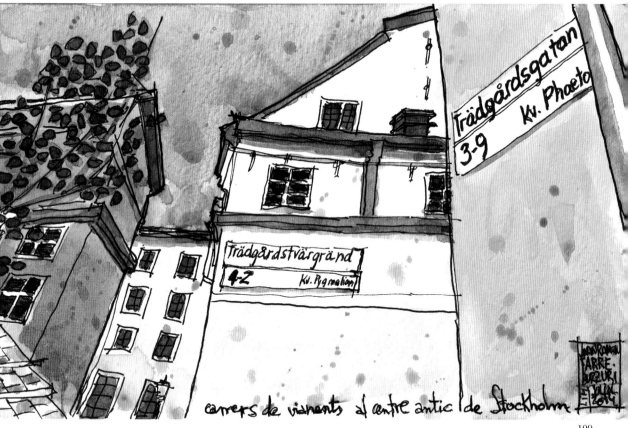

Trädgårdsgatan
3-9 kv. Phaeto

Trädgårdstvärgränd
4-2 kv. Pygmalion

carrers de vianents al centre antic de Stockholm

109

Pushing a surface to the limit

Rolf Schroeter

The Deutschlandhalle was an arena in Berlin, Germany, built in the 1930s for sporting events and adapted over time for concerts for the likes of Frank Zappa and Jimi Hendrix until it fell into disrepair. This drawing is one of a series by Rolf over several months that traces its decline from a derelict shell to heaps of rubble after the demolishers moved in. Here it is shown in a semi-dismantled state behind the perimeter fence around a car park.

Rolf's ink drawings on very light calligraphy paper are sometimes lent an extra level of energy from interference emanating through the page from other drawings. The surface wrinkles under the spreading dampness of ink and watercolour, and colours applied with a brush blend and blur. The spidery but expressive lines come from a pointed steel dip pen with black and red student drawing ink.

'The paper absorbs any mark or wash immediately,' Rolf says. 'Corrections on the wet paper are impossible, and lines can only be executed before the washes, as the paper rips when treated with any pen in a wet state. I used this paper as I felt its features matched the non-reversibility of any step of the demolition.'

JAFFESTRASSE_250112
Medium: dip pen and brush
with ink and watercolour
Dimensions: 18 x 27 cm

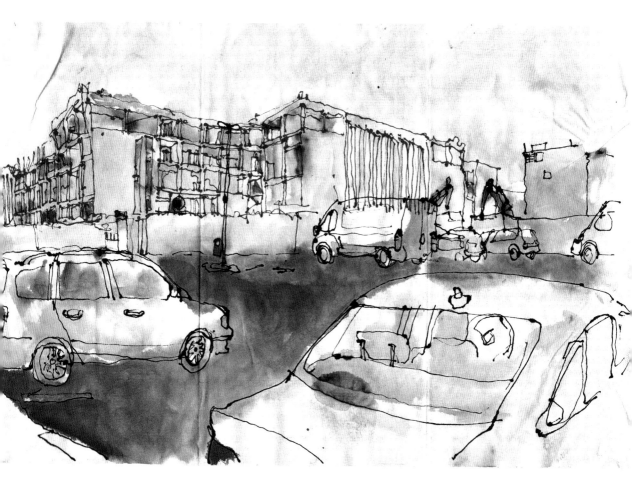

Lines and washes in ink

Pamela Grace

The bronzes and golds among the fading greens of the hedgerow and the dense seed heads capture the character of a Scottish landscape at the end of summer. The intertwined lines and shapes of the cow parsley and other wild plants found along the verge of a farm track in the countryside around Pamela's home stand out clearly like a screen against a simple backdrop of fields and copses that recede into the distance.

Inks are ideal for linear work as well as for washes of colour. On a heavy watercolour paper, Pamela used a warm black or Payne's grey to make the original lines using dip pens, and then coloured inks with a little watercolour for the wash work, rolling the colours on using Japanese paintbrushes.

Familiarity with the landscape throughout the year can bring an added depth to a painting. 'I walk the dog past this hillside on an almost daily basis and I have painted it from many different viewpoints,' Pamela says. 'I enjoy the subtle variations in the seasons and try to capture them in my work. I like to work outside as much as possible, and the lovely autumn sunshine made this a pleasure, allowing me to concentrate on the details of the landscape.'

SEPTEMBER VIEW
Medium: pen and ink
Dimensions: 56 x 46 cm

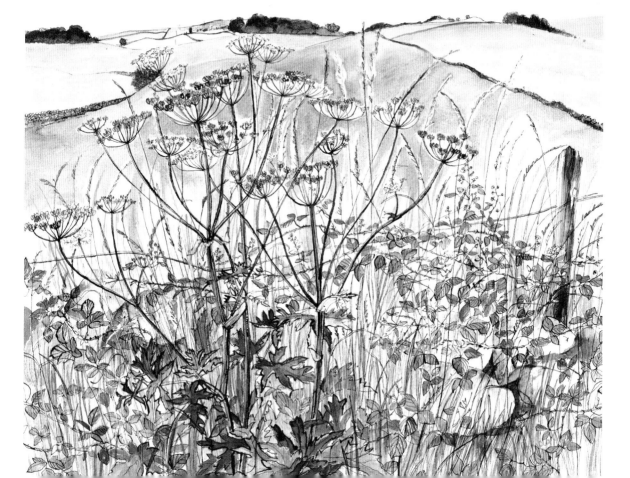

Working from preliminary sketches

Fraser Scarfe

This image of thick foliage was drawn from the window of a studio at Dumfries House, Scotland, where Fraser was artist in residence in 2014. His process towards a finished painting involves first making a series of very small sketchbook drawings, in this case 10, that enable him to resolve the composition before starting a large drawing such as this.

Fraser always refers to drawings when he is painting, and any finalised painted works may be the result of 20 or more quick compositional drawings. 'Drawing is a fundamental stage of my painting process that helps me to flesh out ideas and, more importantly, become more familiar with my subject,' he says. 'I tend to stick with ink because I like the directness of the marks and the range of greys achievable as the pens run out. In practical terms, marker pens are very easy to carry and use, and don't require sharpening or refilling.'

One of the characteristics of drawing with ink, its unequivocal permanence, may be considered a drawback by some artists. Once marks are on the paper, there is no chance of going back. But this can also be recognised as one of its strengths. 'The inability to erase marks is quite thrilling,' Fraser says.

TREES AT DUMFRIES
Medium: waterproof ink marker pens
Dimensions: 60 x 84 cm

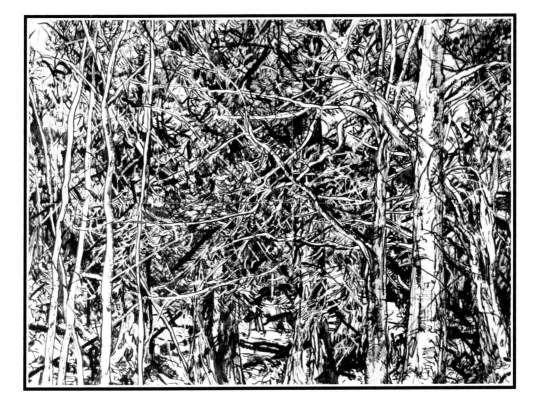

Making space work

Cynthia Barlow Marrs

With pen and ink, as with other media, the white of the paper can play as large a part in the composition of an image as the drawn areas. In Cynthia's drawing of the interior of a restaurant the white of the paper merges with figures in the foreground: the daily specials menu blends into the head of the figure on the left, and a white band that runs along the wall in the midground drops into the V-neck of his sweater.

The drawing, across an open sketchbook using a fine pigment pen, includes a varied and entertaining assortment of applications and tones, from the vigorous lines of the man's hair to densely hatched blacks. It is a drawing that invites and rewards close study.

'I like to balance open areas, such as the 'empty space' background on the right, with corresponding areas rich in marks, such as the main figure and the brick wall,' Cynthia says. She uses a range of pen sizes, from 0.05 to 0.8, depending upon the effect she requires. 'If I need to reduce my kit to a minimum, I carry just the 0.05 and, say, a 0.3.'

MIND OVER MENU
Medium: pigment liner pen
Dimensions: 20 x 28 cm

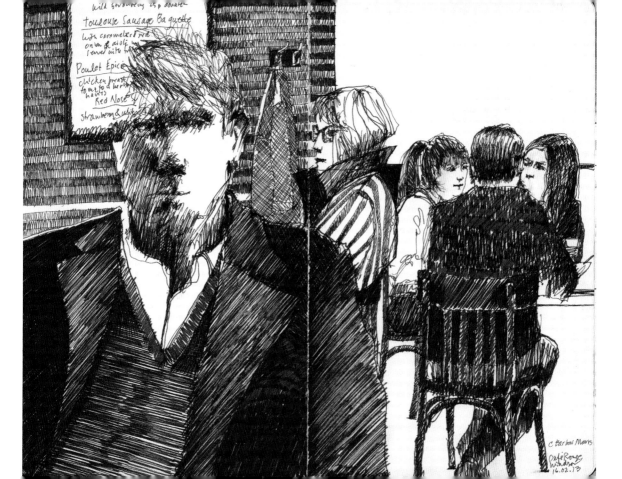

Skylines from above

Amer Ismail

Rising high into the sky to look down and draw a scene, especially one of a cityscape, can be a disorientating experience. Suddenly most of the action is below eye level instead of above it, and the decisions made about perspective that may have become second nature when drawing at street level have to be carefully reconsidered. The scenes on the street become distant, and viewed almost from overhead, and human beings become ant-like.

Amer drew this view of the bustling commercial district of Shinjuku from a photograph taken in the Tokyo Metropolitan Government Building, which has a free observation deck on its 45th floor, more than 650 feet up. His painstaking focus on line using a fine pen draws our eye past the dense network of buildings in the background towards the horizon shown by just a few marks on the right hand page. The shadows cast on the foreground towers and the street below are drawn with pencil.

'As an architect and urban designer, it is always fascinating to see the different skylines of the cities I visit, even more so with Tokyo, the most populous urban area in the world today,' Amer says.

AERIAL VIEW OF SHINJUKU, TOKYO
Medium: pigment liner pen
Dimensions: 20 x 28 cm

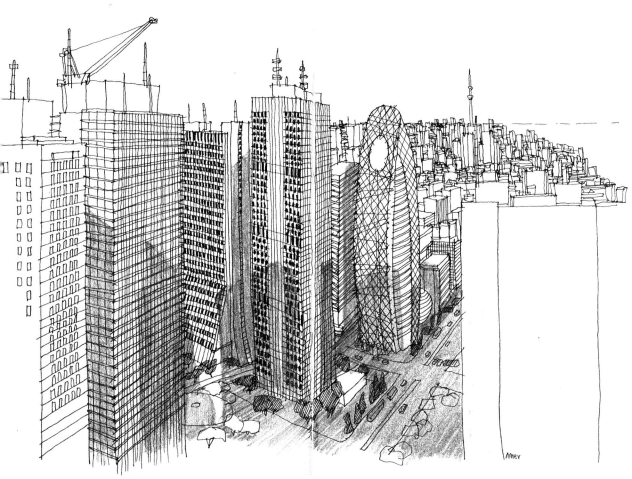

Find an ink to suit your style

Nicholas Di Genova

This group of four crow images was commissioned by the band Hank and the No Goods for a tribute album to the First Nations artist and campaigner Willie Dunn, best known for his short film *The Ballad of Crowfoot.* Nicholas worked first on rough drawings in his sketchbook from a range of photographs and images he had gathered without following any one source too closely. Then, for the final images, he laid each out in pencil first to ensure the proportions were correct, before moving to dip pen and ink.

He used fine nibs with India ink that had a high carbon content to bring out the rich blackness of the subject. 'Some black inks are actually dark grey, and when you overlap your strokes you can see that those parts are darker,' he says. 'With this ink, each stroke you lay down is a gorgeous deep black, and the finish is a beautiful satin.'

There is a personal angle to the advantages and disadvantages of every type of ink. Experiment and explore to find the materials that suit your way of working and how your work will be used: lightfast pigment inks for exhibits, and water-resistant or waterproof India and sumi inks if subsequent washes will be added, for instance.

CROWS
Medium: dip pen and India ink
Dimensions: 8 x 10 cm each

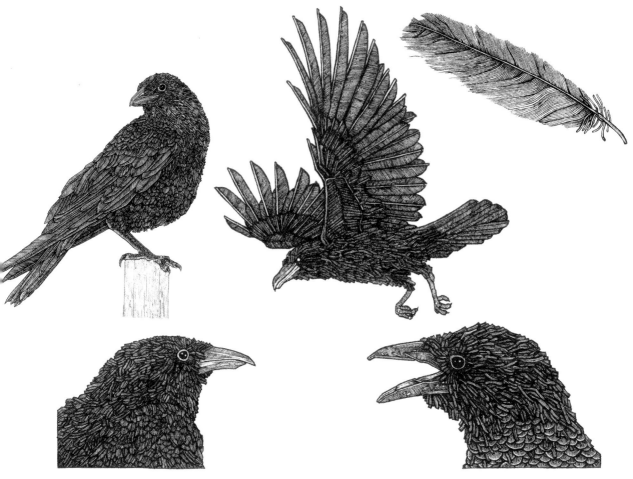

Pattern making

Caroline Didou

This drawing of the mediaeval buildings of a French city is an exercise in square-on pattern making as well as a record of urban history. Squares, diagonals, stripes, arrows and arches: Caroline has been able to lose herself in the well-regimented decoration embedded in the construction of the buildings. But, as so often in such structures, age and settlement have ensured that things are not as vertical, horizontal or mathematically precise as they at first seem.

The first marks on 300 gsm watercolour paper were with a grey 0.8 mm pen; choosing a waterproof ink will ensure that it holds fast if subsequent layers of wet media are applied to the paper. For the windows, a blue 1.4 mm italic calligraphy pen has been used so each individual glass pane can be portrayed by a single mark. Caroline has also been influenced by how her work will look in relation to contemporary social media trends: a square format to suit photo sharing sites like Instagram™, and a blue theme that works well with community based sites like Facebook™.

On the right-hand side of the image, where the window panes run out and there are a few larger areas of untouched paper, there is the suggestion that the work remains unfinished. 'Generally I do not finish my drawings,' Caroline says. 'I am more interested in the act of drawing than in the result.'

OLD RENNES, MEDIAEVAL HOUSES
Medium: black, grey and blue-grey waterproof pens, blue italic calligraphy pen, watercolour
Dimensions: 30 x 30 cm

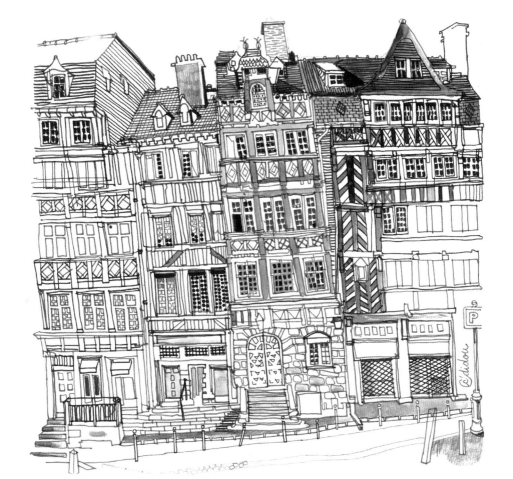

Expanding the image

Fraser Scarfe

One of the great advantages of using pen and ink is just how minimal and portable a medium it can be. Sheets of paper are compact and light, ink usually dries very quickly and all the materials you may need for a day of drawing can fit into a small bag, or even a pocket.

But what about when the subject suggests that you need to start working larger? How big can things go? Fraser started this work as a small sketchbook drawing of part of a tree, 'but it demanded a bigger image, so I continued to add sketchbook pages, taping them together as I worked', he says. The finished work, of a broader panorama of Kensington Gardens, London, than he had first intended, consists of 18 assembled sheets of drawing paper.

This expanded outlook introduces new elements: the line of a fence to the left, the silhouette of distant trees to the right and the suggestion of a path in the foreground. The variety of marks – more considered in the background and gestural in the front left – is extended also, using a range of sizes of waterproof ink pens. Look around as you draw to see which directions things can go.

TREE STUDY, KENSINGTON GARDENS
Medium: waterproof ink marker pens
Dimensions: 60 x 84 cm

Draw absentmindedly

Nicholas Di Genova

This drawing was done on simple lined paper as Nicholas sat down to watch a movie with his girlfriend: he just grabbed the nearest book, which happened to be about frogs, and 'absentmindedly doodled away' as they hung out. The frogs he drew with a fine dip pen – a fantastic collection of tones and textures that have been fitted into the page however they would fit.

Working in such a relaxed way – especially when there is no aim except to enjoy the process of drawing – encourages freshness and experimentation and, inevitably, occasional failures. Nicholas has set himself a rule he tries to adhere to that if he starts a drawing, he finishes it. 'That way I can't repeatedly scrap pieces when the first few stages don't go exactly as planned. If I didn't have this rule, I could see myself repeatedly trashing things in the early stages and never finishing anything.'

Mistakes can sometimes be incorporated into a drawing, but these works, he says, often turn out to be a failure. 'Those are the pieces that go into the bottom drawer of the flat file and never come out.'

FROG STUDY
Medium: dip pen and ink
Dimensions: 22 x 25 cm

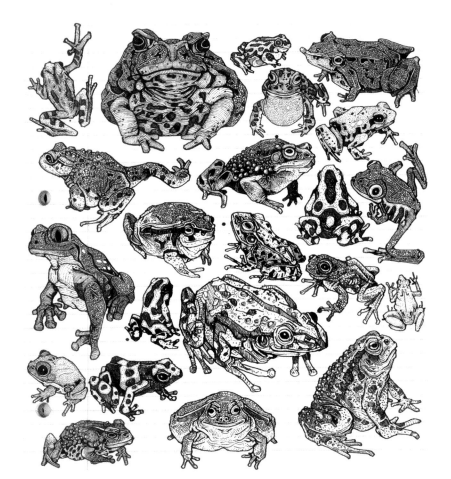

Mark-making and gesture

Dalit Leon

Dalit's untitled drawing is part of her ongoing series of works in India ink. The works explore pictorial space in relation to landscapes and dreamscapes. 'These drawings have no specific objective reference,' she says, 'and can be described as journeys beyond the picture plane through an evolving pictorial path.'

Because of ink's 'irreversibility' – what goes down on the paper generally stays on the paper – Dalit says the medium 'requires a focus and an intent that are particular to it. It has a tendency to create unexpected events on paper, which endow the process with both meditative and exciting properties.'

Light and midtone washes that explore mark-making and gesture are made with ink, primarily with a brush (although sometimes with water only), while subsequent layers play a more descriptive role in response to the earlier marks.

Each layer is a reaction to the ones that preceded it. The final layers are applied to the heavy cartridge paper with a mapping or dip pen, and a brush, bringing in the darker tones to articulate the space. 'The beauty of a mapping pen is that it responds to pressure so the thickness of line can be varied significantly within a continuous mark,' Dalit says.

**UNTITLED
(PEN AND INK 16)**
Medium: pen and India ink wash
Dimensions: 22 x 15 cm

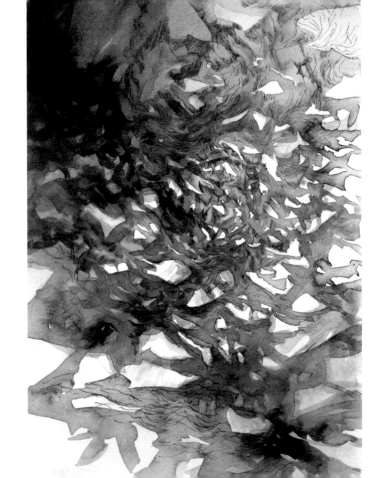

The precision of pens

Caroline Didou

The lines in this drawing lead us across the cobbled street and around the corner past the church. There are few signals to suggest when it was done – no cars, people or TV aerials are visible to date it. It is the approach that Caroline has adopted, a mix of pen and ink and other media, including coloured pencils, in black and blue, that give it a contemporary feel.

While attempting to draw every single cobblestone and roof tile can sometimes be a step too far towards accuracy, here the 0.8 mm black pen on 170 gsm paper can offer the kind of precision to make it succeed. Areas of darker shade are shown with a 1.4 mm blue pen, and the occasional touch of watercolour. Caroline's aim as she works, she says, is to spend more time looking at her subject than at the drawing she is making.

Her use of just the colour blue in her work, she says, simplifies her working process, and makes reproducing the images more straightforward. It is also inspired by the traditional blueprint method of reproducing architectural plans, an area of interest that is central to her work.

OLD RENNES
Medium: pen and ink, watercolour, coloured pencils
Dimensions: 30 x 30 cm

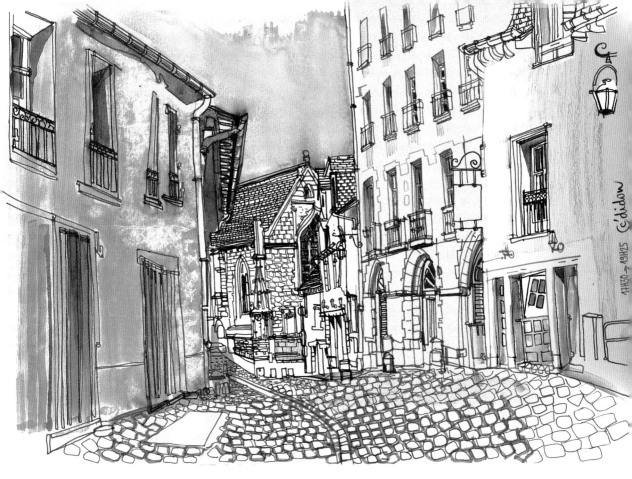

Drawing an absence

Olivia Kemp

There are times when a drawing is as much about what isn't there as what is. Olivia returned to a location in Italy that she had visited previously to draw an old playhouse that had caught her attention, but in the intervening year it had been taken away. The clearing where the structure once stood remains among the trees, and so this is what she drew.

The Cold Clearing is a large drawing, done with a fine pen, and its remarkable detail could almost lead us into thinking we could turn detective and find clues as to how and why the structure has disappeared. Olivia does, in fact, reward those who look closely by hiding things in her drawings. (There is, for instance, a lizard in the foreground of this drawing that may be found by the eagle-eyed.)

'As with all my drawings, I do not sketch out in pencil or pen first,' Olivia says. 'They grow out of a certain point. The intense thoughtfulness this requires is what pulls me to the medium. I like the mark to be permanent, meant and thought about. I want it still to be there when I finish the work, like a stitch in a tapestry.'

THE COLD CLEARING
Medium: waterproof pigment ink pen
Dimensions: 60 x 95 cm

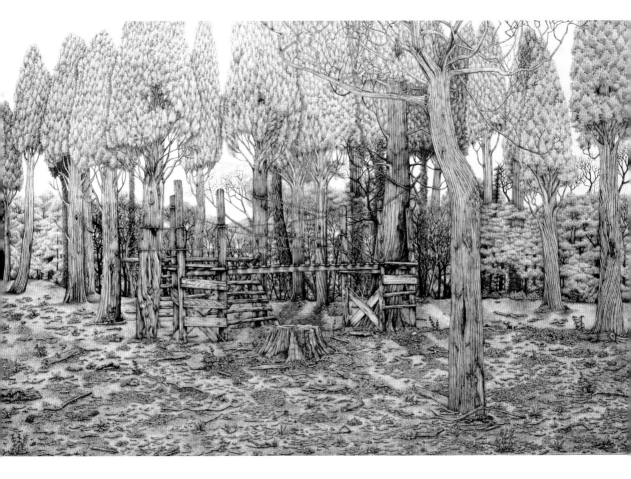

At one with nature

Ch'ng Kiah Kiean

The character of this traditional Malay house in Pantai Cenang, Langkawi, off the Malaysian coast, is powerfully communicated in this drawing. This is enhanced by the way its frontage suggests an anthropomorphic presence of a hunched figure, perhaps, or an insect.

The drawing was part of a series Kiah Kiean was commissioned to complete of traditional houses and village scenes, so architectural accuracy was an important factor, but into this he has brought his own lively style. The roof tiles and the way the light is shown falling across the steps are meticulously shown, for instance. Into the predominantly black and grey composition in waterproof Chinese ink have been added a few touches of brown and blue watercolour to highlight its presence. These combine to make an image that is strikingly bold – it doesn't contain a single tentative mark.

The house seems to be a part of the natural world around it, growing on stilts and hugging the shade of the trees to counter the high temperatures and humidity of its environment. Even the way the house leans slightly to one side follows the line of the tree it stands beside.

PANTAI CENANG, LANGKAWI I
Medium: dry twigs with Chinese ink and watercolour
Dimensions: 76 x 76 cm

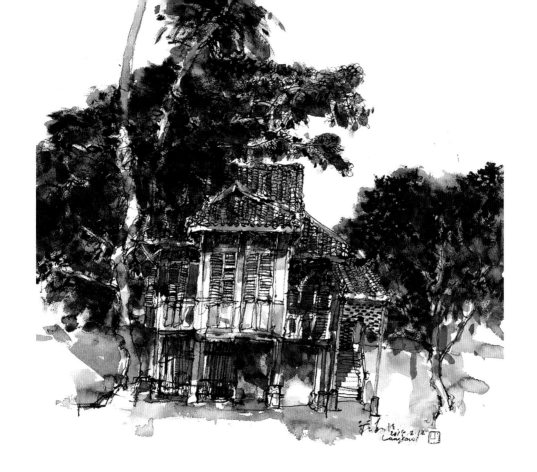

Langkawi

135

Textured surfaces

Cynthia Barlow Marrs

This wintry, atmospheric, imaginary snow scene uses the coolness of ink's natural properties to its advantage through a series of subtle, misty veils of manipulated ink. It is painted as a triptych on medium-density fibreboard (MDF) panels that have been treated with three layers of sealant and then two layers of acrylic gesso.

The sweeping, textured brush marks left by the dry gesso contribute to the effects left by the subsequent layers of ink Cynthia has applied to suggest clouds or passing bands of snow. 'When I brush undiluted ink over paper or small panels, I cannot stop myself rinsing it off before it dries, just to see what happens,' she says. 'The result is intriguing ghost marks or skeleton shapes that I cannot obtain in any other way.'

'It's a messy and unpredictable process,' Cynthia adds. 'To rinse off the ink I use a spray bottle at the sink or hold the artwork directly under the tap, or sometimes I do both. Panels, of course, must be kept as dry as possible. This brushing on and rinsing off gave rise to many of the distinctive marks in the piece; for example, the horizon line and most of the leaves.'

SNOW (TRIPTYCH)
Medium: gesso and Chinese ink on panel
Dimensions: 23 x 23 cm

Nature's variety of textures

Wendy Winfield

Nature offers artists the greatest range of inspiration imaginable, should we be prepared to take up the challenge. Its textures and rhythms go far beyond what the human imagination can conjure up, and its diversity and seasonal changes mean there is more than a lifetime's work for anybody.

This drawing of the southern French landscape was done on a cold, wet day from inside a car with the windows rolled down. The marks range from scuffed marks from a semi-dry hog hair brush; an area of deep, rich black on the left that seems to have been smeared on; quick, fine strokes from a fine steel nib for the grasses, which recede in scale towards the background; and lightly stabbed dots of ink in the distant fields.

Along with the zigzagged patterns used to represent the undergrowth in the middle ground, this wide variety of marks suggests a relaxed enjoyment of the opportunities this landscape has presented, as our eyes are drawn down the track toward the horizon.

RAINY DAY NEAR GORDES, FRANCE
Medium: pen and India ink
Dimensions: 20 x 30 cm

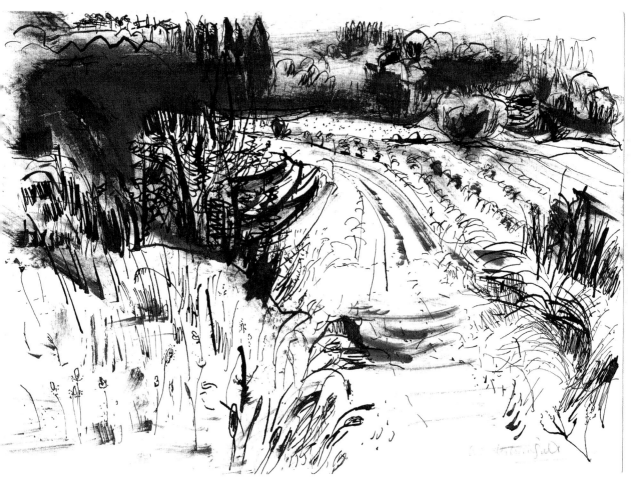

Keep things loose

James Hobbs

The natural introduction to drawing for most people, understandably, is to start tentatively and with the lightest marks in an erasable medium for fear of making a 'mistake'. (Charcoal is a great medium to learn with, an encouragement to work bold and big, knowing that marks can be erased and drawn over.)

So loosening up with a permanent medium like pen and ink can seem an intimidating prospect. We should look to find our own way of working and the techniques that suit us best, but drawing with pen and ink doesn't have to mean meticulous pencil underdrawings or half-hearted mark-making. With experience, experimentation and the occasional failure comes growing confidence.

One of the best reasons for keeping less successful works is to recognise the strides forward that we have made over time. The lines in this drawing are loose and rarely straight, yet they suggest a real, everyday scene. By paying heed to such basics as perspective, and making the subjects solid forms so that they don't appear to float in the air, there is still scope for looseness and extravagance in the lines.

OVER CHEAPSIDE
Medium: marker pen
and watercolour wash
Dimensions: 15 x 20 cm

Drawing as calligraphy

Ch'ng Kiah Kiean

Kiah Kiean's drawing of a street scene in the town of Hadyai in southern Thailand brings together his distinctive dancing line with loose areas of wash to explore the buildings' patterns and rhythms. The edges of the buildings fade to the white of the cartridge paper, with just a few lines to suggest the shapes they take: the surface is more important than the form.

Rather than including crowds of shoppers to show it as a busy commercial area, Kiah Kiean has left it to the lettering and signage to be found in the scene. Shops and markets inevitably mean signs, posters and advertising, an essential element to include in drawings to capture the character and atmosphere of a place.

As the predominantly Thai script was foreign to him – he was visiting a friend from over the border in Malaysia – each sign had to be copied with care into the drawing. The lettering became an element of the composition that needed the same analytical eye as the architectural features for it to be convincing. In parts of the drawing the patterns formed by the buildings' windows have been drawn by Kiah Kiean almost as calligraphic characters, echoing the signage.

HADYAI SHOPHOUSES
Medium: fountain pen and wash
Dimensions: 38 x 28 cm

WONG SHUN HING

Vitalux

黃莉發 有限何

恭昌行金行

2012.3.30
Hong Kong

Blurring boundaries

Tyga Helme

The Phoenix Garden is a small open space in Soho, central London, and a place to which Tyga has gone many times to draw. By returning to the same subject, our knowledge of it increases, and this can feed into the work. Drawings build on past memories, and the spontaneous act of working outside is coupled with a greater experience of the place, Tyga says. 'I am interested in stretching out the observed moment into many, so that the past and the present are in continuous dialogue.'

She used ink slightly diluted with water so that she could work quickly and keep up a constant rhythm. The marks cover the whole page and there is no sign that it shows a scene from the centre of a large city. The boundaries become blurred, and our eyes move around the page looking for somewhere to settle.

'Drawing is the stem of all my work,' Tyga says. 'It keeps me alive to the world around me and is constantly challenging. You can never be complacent or have preconceptions about what you are seeing.'

THE PHOENIX GARDEN
Medium: bamboo pen and brown ink
Dimensions: 53 x 74 cm

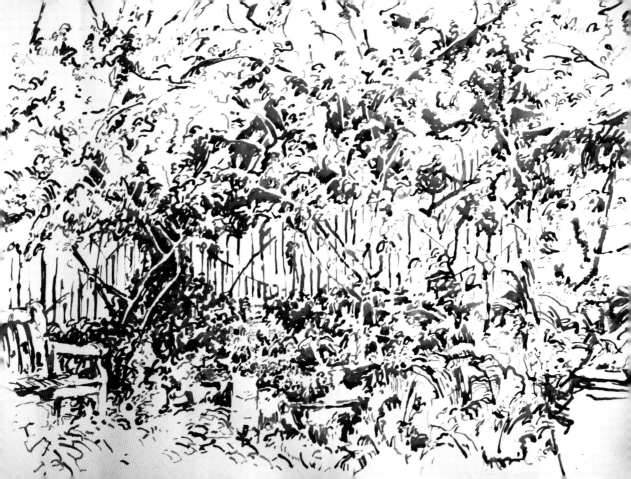

Surrealism with ink

Loui Jover

One of the great qualities of pen and ink is the direct and immediate way a concept can be communicated. This image is one of a series of works created by Loui from doodles and sketches in which he explored the idea of portraying men in suits with surrealist heads to suggest their characters. The figure is drawn in ink in a loose, relaxed way, with the outermost edges of the jacket and trousers left white to suggest they are illuminated from behind by a strong, invisible light source.

The sight of a tree with birds emerging from the shirt collar turns the figure into an arresting and thought-provoking image. Is this a man trapped in conformity who would sooner be embraced by nature? Why is the tree leafless, as if shown in the middle of winter? The dark black silhouette of the trees and birds are in contrast to the sculpted tonal forms of the man.

Loui uses a variety of dip pen nibs, some of them vintage, including a crow quill nib and a favourite, a No. 9. 'I don't use calligraphy nibs as they are generally rounded and offer too constant a line,' he says. 'I like to vary pressure to control the line's width and darkness.'

NATURAL MAN
Medium: brush and dip pen with sumi ink
Dimensions: 58 x 41 cm

A sense of abandonment

Olivia Kemp

Orford Ness is a nature reserve on England's eastern coast known for its rich wildlife and the longest vegetated shingle spit in Europe. But it is also home to a former atomic weapons research centre, still open for tours, that is now left to the elements. It was this sense of abandonment of the site, close to where her family live, that attracted Olivia to draw it. 'This idea of a place that is slowly disappearing instantly fascinated me,' she says. 'When I finally went there I knew straight away that it would be an important place for me.'

The drawing is large – it takes strides to walk across it – which somehow adds to the sense of desolation. It was the first drawing Olivia had attempted on such a size, 'but the scale of the buildings and the site demanded it of me', she says. Using a fine pen for such a format meant the drawing took three months to complete. She worked from a combination of photographs, other drawings and, finally, her own imagination.

The geometry, straight lines and rhythm to the buildings are gradually being softened and overpowered by the return of nature's forces, as depicted in fine detail by Olivia's pen.

AND YET THE RUBBLE THRIVED
Medium: waterproof pigment ink pen
Dimensions: 76 x 118 cm

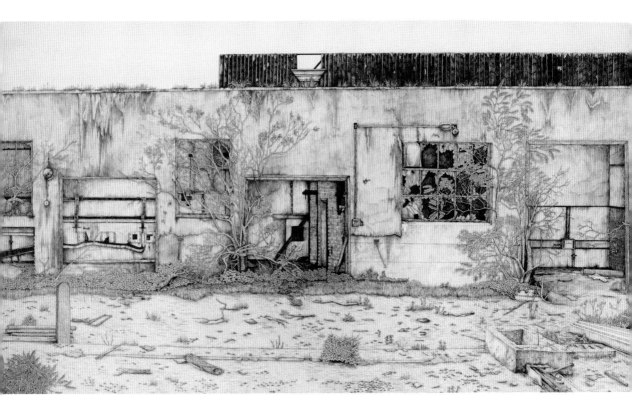

Moving space

Tyga Helme

This drawing of trees on Hampstead Heath, London, was the first step to a large body of work on the same theme by Tyga that she continued in visits over many months. The two trees come together through a range of marks that search for a different language to describe the static trunks against the continually moving and elusive nature of the foliage and leaves.

Every inch of the surface of the paper has been used to create the impression that we are surrounded by a swirling mass of greenery. The variety of tones in the ink's marks are due to the change in speed of the loaded bamboo pen on the paper: the lighter marks have been applied more quickly. It results in a feeling of airiness, space, depth and movement. The drawing embraces the space between the trees as much as the trees themselves.

The poet Rainer Maria Rilke's lines resonated with Tyga when she read them later. Rilke wrote: 'These trees are magnificent, but even more magnificent is the sublime and moving space between them, as though with their growth it too increased.'

TWO TREES
Medium: bamboo pen and ink
Dimensions: 30 x 40 cm

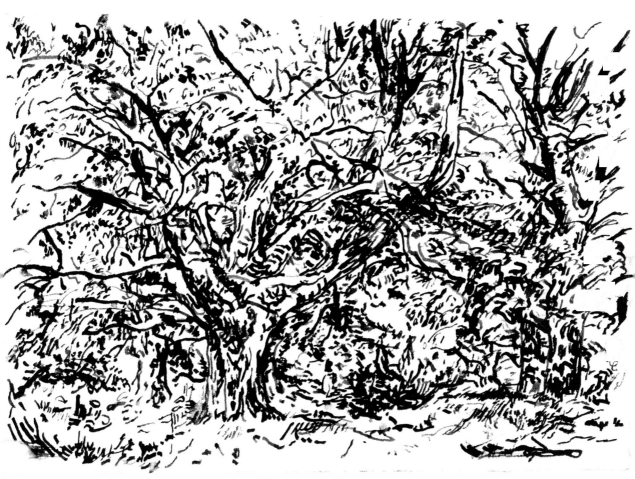

Reach into the imagination

Nicholas Di Genova

The body of a tortoise has been brought together with the mouth of an anglerfish, which uses a lure to tempt its prey within eating distance, to create this unlikely looking creature from the imagination of Nicholas. The drawing is part of a series featuring mutant creations that Nicholas, who has a background in street art and comic books, has exhibited internationally. His fine, analytical style in dense black lends them a menacing and grotesque air.

The drawing is on 200 gsm hot press paper, which is ideally suited to such detailed work. Hot press refers to its smooth finish (in contrast to the undulating surface of cold press paper). Fine dip pen nibs, as used by Nicholas, glide smoothly across the less textured surface of hot press. Less ink is absorbed, and it dries more quickly than on cold press surfaces, which can be a useful quality.

Some artists prefer a Bristol board, a heavy paper suitable for a variety of media, which can be even smoother than hot press watercolour paper, 'but these are usually bright white and don't seem to have life the way a watercolour paper does', Nicholas says.

ANGLER TORTOISE
Medium: dip pen and India ink
Dimensions: 35 x 45 cm

153

Hatching with delicate lines

Michelle Cioccoloni

Michelle's depiction of a 2,000-year-old Chinese glass dish may at first glance suggest it hasn't been drawn with ink at all. The technique she uses is a form of hatching with delicate lines that are gradually built up in such a way that there is no sign of the artist's hand. It was drawn from observation as part of a series of works that feature vessels and pots in museum collections.

Her interest in such ancient artefacts stems from their direct link to people and places that are now very remote. 'It is remarkable that such a small, delicate form has lasted so long in time,' she says. 'Often the subjects of the drawings are humble, everyday objects from ancient civilisations. Today their meaning and the way we look at them has changed. Placed in a museum cabinet, each object is as if stilled, paused.'

Michelle often starts with several quick sketches from which an idea will present itself before she moves on to the main drawing. This composition plays on the tension of the rendering of the three-dimensional object and the arrangement of grey shapes on the heavy handmade watercolour paper. It is a starkly simple drawing of an object, the surface it sits on and the shadows cast across it.

GLASS DISH
Medium: pen and ink
Dimensions: 8 x 20 cm

Silhouettes

Loui Jover

Visiting an annual local fair, Loui made a series of sketches and drawings of a swing ride that had captured his attention. 'I was struck by the silhouette of the people hanging from the ride, how vulnerable they were and how they looked like dangling puppets,' he says. 'And it brought back memories I had of attending the same fair as a child.'

Back in the studio he used the photographs and sketches to make quick drawings in an attempt to capture the movement and outline rather than getting involved in too much detail. 'I wanted an almost calligraphic element to the work. I chose this drawing as my favourite from the set – I destroyed the others – because although only black shapes represent the figures, I could sense their individuality even in this simplified form. I liked their sense of isolation from each other even though they were riding together.'

The strength of this work springs from its simplicity, the subtle balance of black ink and white paper, light and dark, and the negative spaces they form. The title of the work, *Sugar Mountain*, comes from the Neil Young song about a fairground that Loui listened to as a child.

SUGAR MOUNTAIN
Medium: brush and sumi ink
Dimensions: 41 x 58 cm

Finding a sense of place

Michelle Cioccoloni

One of the immediately striking aspects of this drawing of artificial flowers is its series of contrasting elements. The background is formed from geometric shapes of subtly shifting tones that create a long horizontal line on the right-hand side of the work where the lightest and darkest areas meet, and a strong vertical line acting as a bookend on the left. The flowers in a decorated container in the foreground sing out against this background.

The drawing was a commission for a stately home where flower arrangements were on display throughout the rooms. 'I wanted to capture the feeling of the place and the way certain details stick in our mind – our memory of a place,' Michelle says. 'Most of the flowers on display in the house were artificial, silk flowers, and yet they were very convincing. I wanted to breathe life into them. It seems that the light is coming from the flowers themselves, giving the drawing a magical, otherworldly mood.'

Even though some of Michelle's drawings can take days to complete, it is not a 'slow' process, she says: 'Drawing requires careful scrutiny but the process is always exciting since I work from life and discover new aspects of my subject as the drawing progresses.'

ARTIFICIAL FLOWERS
Medium: pen and ink
Dimensions: 15 x 23 cm

Reportage and ink

Joe Munro

Joe's drawing of a pianist, done while reporting from a Cary Grant festival, unites the broad, black sweeps of the grand piano – drawn in India ink applied with a brush – with finer, more precise elements done with a dip pen that show the performer's profile and the interior of the instrument. The gestural black of the piano and its top board and prop combine to create a frame within which the pianist is set. His changing profile is shown almost as an illustrative flick-book sequence to suggest the passing of time as he plays, so it is possible to imagine the performer working his way between high and low notes.

Ink – often with marker or brush pens – is a popular medium with reportage artists such as Joe who are working on location. 'Working this way means you can't reach for an eraser,' he says. 'You have to work instinctively, making bold marks and strokes, capturing the movement and pace of the unfolding events in front of you.'

Joe's practice stems from the primary, visual journalistic principles of illustration: documenting, interviewing and investigating his subject matter on location. These raw marks and forms are filtered through a studio-based process to produce dynamic and engaging works.

THE ENTERTAINER
Medium: India ink, dip pen and brushes
Dimensions: 28 x 43 cm

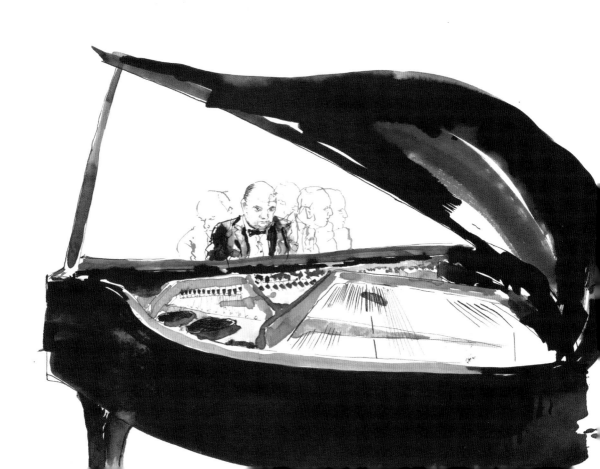

Receding layers

<div align="right">**Olivia Kemp**</div>

The variety of layers in this drawing – the foreground, middle ground and background are segregated by receding fences, gates and trees on sloping ground – made it a deceptively complex scene to draw, Olivia admits. Each layer of fencing has a distinctive grid through which foliage is visible. The precision of a black pen on a large scale makes it a scene of alluring detail.

It immediately appears to be an unremarkable scene that is unlikely to feature in a work of art, but Olivia was commissioned by a couple to make this drawing, which is the view opposite their house. By having it drawn, they hoped to be able to see it in a new, interesting light, and take their view with them should they ever move house.

Stopping to draw and spend time with a subject can help us to see a place in a refreshed way, just as it can for those who live with it when finished.

Olivia's approach of using a single black pen allowed her to record the detail of the scene but with her own distinctive vision. 'I enjoy getting commissions,' she says, 'but it helps if you feel passionate about someone else's choice of subject matter, especially when you spend a month or more on it, as I do.'

OUT THE SCRUBLAND CREPT
Medium: waterproof pigment ink pen
Dimensions: 59 x 84 cm

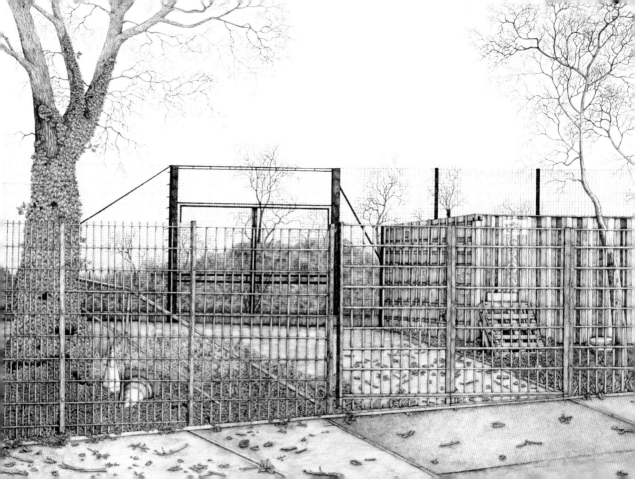

Negative space

Loui Jover

Loui used Japanese sumi ink with a bamboo brush to initially draw this scene from a photographic reference on a very large sheet of paper laid flat on his studio floor. Bamboo brushes come to a fine point, allowing the weight of line to be varied with pressure. 'I use sumi ink primarily because it is possible to re-wet the work and create more graduations or washes of tone,' he says. 'I find India ink dries too fast and becomes permanent too quickly for the work I want to produce.'

He continued by pinning the work to his studio wall in order to fill in more lucid and painterly ink to allow it to run and to create a sense of movement. The resulting 1930s scene, while unmistakably based on a period photograph, is given a contemporary feel.

A few midtones have been introduced by re-wetting the sumi ink, but the scene is predominantly black and white. The densest areas of crowds make fantastic expressive use of negative space to suggest a flowing mass of people milling about. Some areas look as if white ink has been used on black paper rather than the other way around.

1930
Medium: brush and sumi ink
Dimensions: 89 x 150 cm

Working from dark to light

Eleni Kalorkoti

This image was part of a personal zine project, titled *Super Hero*, that explored comic book covers and 'attempted to capture the feeling of lying about in your bedroom looking through comics and zines and things', Eleni says. She had set herself the target of making a zine a month for a year.

Working with water-resistant black ink over pencil outlines, Eleni started by inking in the darkest parts of the image and then watering down the ink as she reached lighter areas. Some artists build up from light to dark with multiple layers of wash, but Eleni finds that the image can become muddy and indistinct if she works in that manner. The edges remain crisp, and the blacks and greys are rich against the white of the paper.

'I used to work in very flat colour – both digitally and in screen prints – before I moved towards inks,' she says. 'I like that you can still get a flat and precise area of colour with ink but that it has an added layer of textural/painterly interest. And there's more room for accidents, which can only be a good thing.'

MY HERO
Medium: ink wash
Dimensions: 15 x 20 cm

The texture of the undergrowth

Wendy Winfield

The verdant lushness of the vegetation that flows through the palm house at Kew's Royal Botanic Gardens in London comes across in this drawing even without any reference to colour. The smooth finish of the off-white hot press paper lends the inky marks an appealing softness and roundedness that reflects the organic nature of the subject. Smudged midtones, created with a semi-dry brush that has first been dabbed on a cloth to lighten its ink load, and areas of intense blackness suggest dense foliage while still leaving things to our imagination. Marks with a steel nib dip pen and bamboo pen are expressive sweeps and explosions of lines from a single point, like fireworks.

'What I love about using the bamboo pen,' Wendy says, 'is getting a heavy, thick line in one sweep – whereas with a steel nib you may have to go back over it. I often get blots on my drawings but I don't mind about that; it becomes part of the painting.'

Subjects such as this one are opportunities to break free, loosen up and explore the marks pens can make. In the winter, particularly, a heated glasshouse can be an inviting place to spend time at work.

PALM HOUSE, KEW GARDENS
Medium: steel nib pen and bamboo pen
Dimensions: 18 x 28 cm

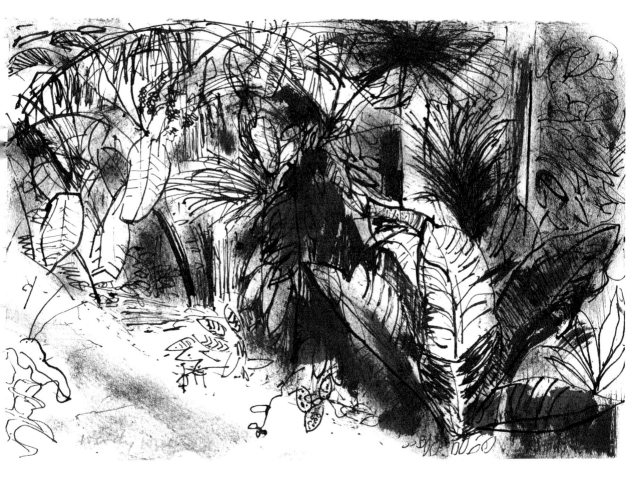

In the heat of the day

Fred Lynch

Finding the right scene to draw can take time. Fred had walked the mediaeval streets of an Italian city for hours on a hot day, hoping to find a worthy subject. It was siesta time, the shops were closed and the streets were almost deserted. With time running out, he turned and saw this view through arches of a succession of light and dark spaces receding into the distance. He drew it quickly with a sense of unease, having to position himself in a private parking space to get the view he wanted.

The image came together through many layers of brown ink – like glazing – on the smooth surface of 200 gsm hot press watercolour paper. Eventually a pedestrian passed by, giving Fred the opportunity to take a photograph so that he could add the silhouetted figure to the drawing later.

'I find myself often drawing architecture not as landscape drawings, but as portraits,' Fred says. 'I'm very focused on the personality of the places and the gesture of forms. My subjects are often simple and direct, unglamorous and unromantic. I try hard to follow my instincts and to honestly capture what draws my attention and pleases my senses.'

SIESTA'S SHADOWS
Medium: ink wash
Dimensions: 25 x 36 cm

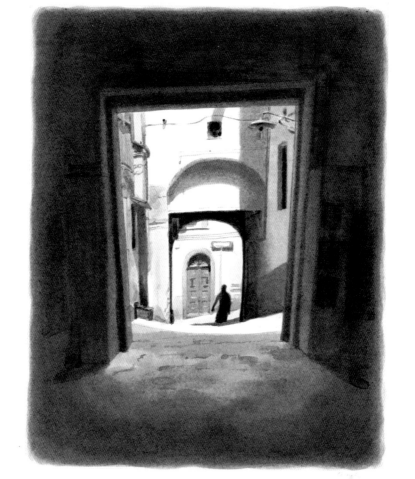

Lines of perspective

Phoebe Atkey

We may be so accustomed to drawing a scene from below, at street level, that taking to the heights and looking over rooftops can force us to reappraise processes we may take for granted, perspective in particular.

This view over the streets of Salzburg, Austria, is a network of routes – roads and river – leading towards the mountains in the distance. We look down almost directly on the closest buildings. The usual process of looking for a horizontal eye-level line across the page is redundant at this height: only the castle in the distance on the right is at our level.

The strong linear aspect of such an urban, architectural view (compared to the more organic lines of a rural subject) makes it a natural subject for pen and ink. Phoebe has worked from a photograph taken on her smartphone – a small image, but one still offering an amazing degree of detail. That detail pulls us into the drawing and leads our eyes around the apparently deserted streets. The city, because of our viewpoint, seems to shrink in size to that of a model village.

ROCK ME AMADEUS
Medium: fineliner pen
Dimensions: 25 x 36 cm

Capturing character

Swasky

Why the names with arrows across the top of this drawing? They are all characters from the play *The House of Bernarda Alba* by Federico García Lorca, drawn here during a rehearsal. The difference from drawing people simply walking in the street is that each actor is playing a known character they have studied and which can be explored through reading or attending the play. The artist can bring their own experience of the character and the play to their drawing.

It is vital to work quickly as the figures move around the stage, but Swasky has used the expressive lines of a fountain pen with the broad strokes of a brush to rapidly capture the postures and attitudes of the actors. By drawing different scenes from the play in a series of drawings, he aimed to get a better sense of each character.

'Drawing a rehearsal is a challenge,' he says. 'I used a fountain pen to draw some guidelines but the freedom I then got facing it with just a brush dipped in ink mixed with water was wonderful.'

THE HOUSE OF BERNARDA ALBA REHEARSAL
Medium: fountain pen, brush and ink
Dimensions: 23 x 30 cm

Despotic

Poncia

Martirio !!!

tirana

Magdalena ???

Poncia

A limited palette

Caroline Didou

This drawing of a quiet back street in a French city captures the scene by making the most of every inch of the page and using the rich variety of lines and marks that pen and ink can offer. The architecture hints at the city's past through its established houses, and its modern development through the tower block that rises in the distance. Everything hints at human habitation, and yet nobody is around, as if it were drawn during a lazy summer lunchtime or under the threat of rain.

One of the results of using a palette as limited as this is that Caroline focuses more strongly on line, rather than reproducing the scene in colour. Her decision to cut back sprang from an occasion when she left her watercolours and tools – 'companions over 15 years' – on the street when drawing, and returned to find them gone.

The tree acts as an umbrella over the scene while the parked bicycles offer a curling swirl of lines across the foreground. The variety of subjects in this single work gives a range of contrasting light and dark areas – the lines of the bicycles and the loose, denser marks of the tree's foliage.

RUE DE DOCTEUR FRANCIS JOLY, RENNES
Medium: waterproof ink pens, watercolour
Dimensions: 28 x 42 cm

A sense of depth

Joan Ramon Farré Burzuri

Stockholm's Old Town is a network of narrow mediaeval streets and historic buildings almost surrounded by water. Joan Ramon's drawing shows a narrow cobbled route towards the waterfront that leads the eye through light and darkness and then light once more. It is almost possible to sense the change in temperature from the warmth of the summer sun to the coolness of the shade under the arch.

A variety of nibs can be bought for fountain pens, but a single nib can be used in a number of ways to create different marks. Different approaches create different effects. 'Pen and ink is the best medium for my style because I can use it with delicacy when I'm tracing thin lines, and at the same time I can add strong and powerful lines with a subtle change of position of the pen,' Joan Ramon says. 'Used in a vertical position it creates a thin line, and at a 45-degree angle it makes a strong line.'

The lines he has used to draw the leaning bicycle contrast with those for the distant waterfront. The latticework of receding cobblestones in lines of various thicknesses further enhances the sense of depth.

GAMLA STAN, STOCKHOLM
Medium: fountain pen and carbon ink with watercolour
Dimensions: 13 x 20 cm

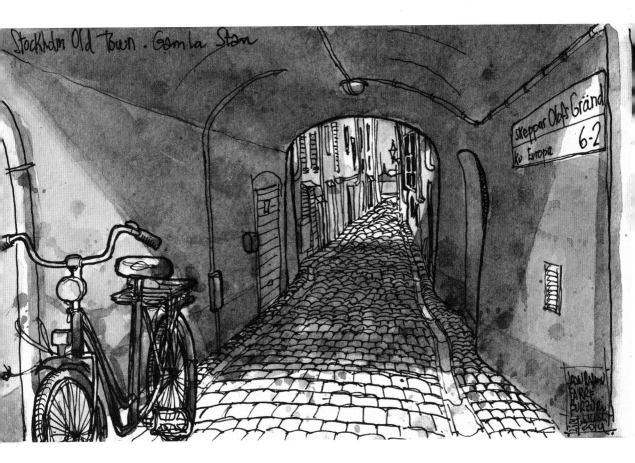

Stockholm Old Town . Gomla Stan

skeppar Olofs Gränd

kv Europa

6-2

Combining chaos and order

Sabine Israel

Chaos and order working together in an image can create an intriguing tension. This scene of a backstreet in Bali started as a pencil drawing done on location. It is an unglamorous subject to draw, a scene that is easily overlooked: the pavement is crumbling, the window shutters hang unevenly, a moped is parked in the gutter. Back at home, Sabine converted the pencil drawing to one in ink by tracing it on to another sheet of paper on a light box, bringing more order through the crispness of 0.1 and 0.3 fineliner pigment pens.

As a background, loosely painted sweeps of acrylic colour have been merged with the drawing using Photoshop to decorate the cracked surface of the wall. The pinks, blues and greys lift the scene's mood. Things may be falling apart, but we can see this backstreet's beautiful side. It is a drawing that encourages us to look for the life and character of a place in the most mundane scene.

MOTORCYCLE IN BALI
Medium: fineliner pens
and acrylic
Dimensions: 30 x 40 cm

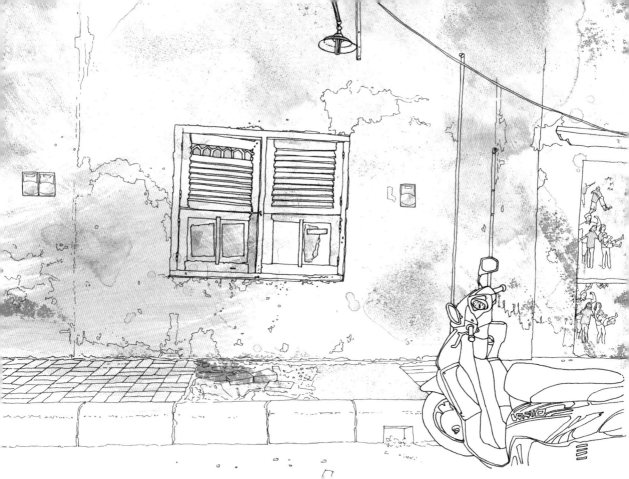

A vigorous approach

Loui Jover

This drawing of the Irish-born painter Francis Bacon is a loose and expressive work from a variety of sources that gives the immediate impression of having been completed mainly by pouring ink down the surface of the paper. There are dribbles and drips and slight tonal variations that come together to capture his likeness. Through these loose, abstract shapes, Bacon's profile emerges robustly from the white, untouched areas of the cartridge paper as much as from the black ones.

When Loui is getting particularly vigorous with the ink he sometimes steps outside his Australian studio to work on an easel standing in a yard. Collaged elements have also been included to create variations to the surface. A yellowed page of text from a ruined book sits on the right-hand edge. The addition of a monochrome image of a woman in period dress is an intentionally obscure allusion to another, much earlier Francis Bacon, the sixteenth-century English philosopher.

Loui uses sumi ink for all of his ink work, India ink being too black and steadfast for his needs, he says. 'Sumi is more flexible and able to be graduated more to my tastes – I like its uneven quality as opposed to the solidity of India ink.'

FRANCIS BACON
Medium: brush and dip pen with sumi ink and collage
Dimensions: 76 x 127 cm

Going with the flow

Jedidiah Dore

'It's always surprising how colourful the desert is,' says Jedidiah. A trip he took to Southern California is encapsulated in this coloured pen and watercolour image. The watercolour aims to capture the feeling of a Californian sunset: the colours merge and flow and were left to dry before the cacti were drawn. But working on the spot can present unexpected problems that may have to be incorporated into a work. Rain, fog or humidity can slow the normal speed of the drying process: 'I don't mind that at all, and the drawing becomes something different.'

A variety of cacti were drawn over the dry washes with different coloured pens until the composition came together. 'The challenge was not thinking too much about the design of the page, and allowing the drawing to simply happen,' Jedidiah says. 'I try to never fight what is happening. There's no such thing as a mistake in a drawing. Mistakes are just differences, in the way we write our signature or the way we draw a cactus flower.'

WILD CALIFORNIA CACTUS FLOWERS
Medium: pen and watercolour
Dimensions: 30 x 46 cm

Collage and layers

Cynthia Barlow Marrs

This image is a mix of techniques and materials, with inks used in a variety of ways. Much of the composition consists of cut watercolour paper on which Cynthia has worked quickly and without much premeditation in ink. For these she included ink used with cut-paper stencils, and in several places lettering written with a dip pen shows through. 'I often use handwriting as a graphic element in my art, partially obscuring what I have written by washing off the ink, or cutting it up and recombining it in collage,' she says.

Having arranged and layered the cut paper reminiscent of feathers on the gesso-treated panel, Cynthia worked on creating a background of a white-on-white dot grid made from gesso mixed with acrylic medium that wouldn't detract from the cut shapes. The long, tapering shapes are hand-cut arcs of heavy watercolour paper.

'Layers fascinate me,' she says, 'and in almost every work of art I experiment with them in one way or another. In my abstract work, if I begin with any kind of plan at all it is almost always to simply experiment, whether with a particular medium or colour or tonal range that I've been thinking about.'

SNOW GOOSE
Medium: Chinese and acrylic inks, gesso and cut paper
Dimensions: 51 x 76 cm

Digital combinations

Sabine Israel

Illustrator Sabine used a variety of techniques for this image of a bird and lilies. Pencil sketches of the bird from the imagination, and the flowers, from life, were translated into an ink drawing on a light table, a flat surface lit from below. Sabine used black acrylic ink with a nib pen on 190 gsm paper for their outlines. 'A pen holder with a metal nib holds so many possibilities,' she says.

The colour element is introduced from a big collection of sheets of paper onto which Sabine has painted freely with a variety of acrylic colours, 'half planned, and half by chance'. (She sometimes includes marble powder in these mixes, which attracts the colour pigments and adds structure to the paint to create interesting effects.) These sheets were arranged and brought together with the ink drawing of the bird and flowers using Photoshop.

The combination of line and colour creates a powerful marriage of finely drawn detail set against a quiet background in the top half of the page, and energetic sweeps and drips in the lower half to represent the lilies.

BIRD WITH LILIES
Medium: pen and acrylic ink
Dimensions: 20 x 30 cm

Finding a fresh view

Chris Lee

'You spend much time looking up in Venice, the bell towers and soaring chapels, and the sound of bells is particularly reminiscent,' Chris says of the Italian city. 'This collision of building styles caught my eye, and there's a real vertical thrust to the scene.'

Venice has long had an irresistible allure for artists. 'It is so full of spectacle, it is hard to focus on specific buildings,' Chris says. This drawing, one of 10 completed by him over a five-day stay in the city, refreshingly avoids the classic views that include the waterways, so that you could be forgiven for thinking it isn't Venice at all.

The viewpoint was, however, partly dictated by rain forcing Chris to shelter on his three-legged stool under the portico of a neighbouring church. There are interesting effects to be had by experimenting with different inks on damp paper, but these weren't the effects he intended for this image: 'I find it impossible to draw if the paper gets wet in the slightest, so keeping dry is crucial.' The detail and precision of the drawing, which has been finished with watercolour, seek to contradict the artist's loose, distinctive line with a very fine pigment liner.

SANTA MARIA GLORIOSA, VENICE
Medium: pigment pen and watercolour
Dimensions: 20 x 28 cm

SANTA MARIA GLORIOSA

191

Urban energy

Jedidiah Dore

Ink is a great medium to capture the energy and vitality of the urban environment – as here, with a variety of colours of line from a dip pen, and vibrant washes. The scene, a busy urban intersection in the heart of Manhattan, is a focal point for people, roads and traffic, where nothing stays still for long. The exploring lines from the pen, the bright washes and areas of crayon are so busy they present no central point of focus. Our eyes are led on a journey around the picture, from café table to busy sidewalk, from rooftops to moving traffic, never finding a place to settle for long.

There is variety in the lines used – from the nib of a calligraphy dip pen and three different colours of ink – to create different pockets of activity that may lead us to look more closely for a while; but this is a drawing, like the city, that never seems to rest.

HERALD SQUARE, NYC
Medium: dip pen, watercolour, crayon
Dimensions: 30 x 46 cm

Ink with watercolour

Ch'ng Kiah Kiean

While using pen and ink may imply images in black, white and a range of greys in-between, there are plenty of colour options that can be used to take an image in other directions. Lightfast and permanent inks for brushes and pens come in various colours, as do marker pens with all kinds of nibs and brush tips. Watercolour is also a popular, portable colour choice for ink users, as used by Kiah Kiean in this vibrant market scene in Malaysia.

The drawn element was executed with his trademark technique of dry twig with Chinese ink. The subtle, graphic line it gives works well with the areas of intense watercolour he added with brushes. He is in a realm he knows well: this drawing shows his father busy working at his stall in the holidays before the Chinese New Year.

Check the small print to ensure the ink you are using is waterproof if you don't want the watercolour to run with the black ink lines. And be prepared to let layers dry before adding subsequent ones unless you want the pigments to blend on the page.

CHOWRASTA MORNING MARKET
Medium: dry twig and Chinese ink and watercolour
Dimensions: 28 x 76 cm

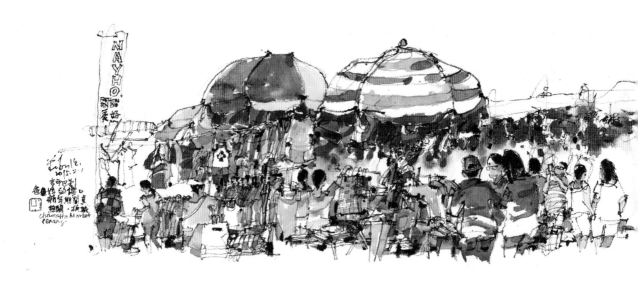

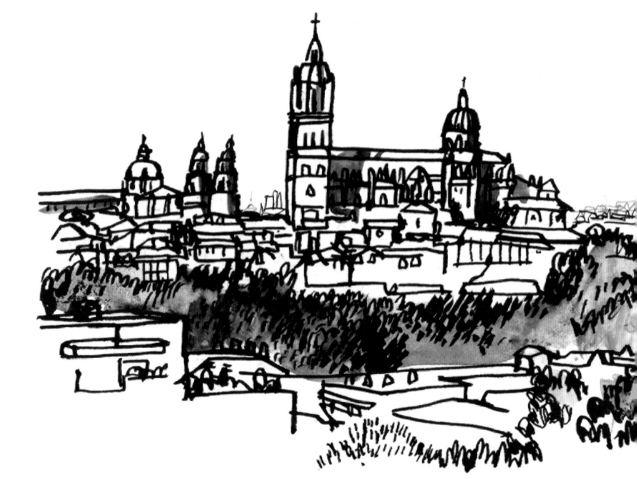

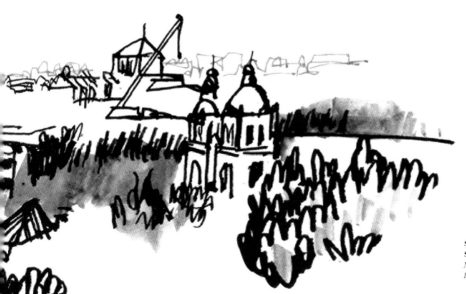

SWASKY,
SALAMANCA SKYLINE
Medium: ink and wash
Dimensions: 10 x 23 cm

Pens

Pens come in a fantastic range. If you don't have a favourite already, take a sketchbook down to your local art materials shop and write the name of each as you try them out to see what they do. There are **fineliners**, **fibre tips**, **technical pens** and **marker pens** that come filled with ink and ready to go. Pens are available in nib sizes thinner than 0.1 mm, and up to 14 mm. Some pens are refillable, or can be used with cartridges, or with different tips at each end. Some contain ink that is permanent, some will blend and move if you make them wet on the paper. Choose a pen with archival ink – pigment-based inks – if your work is going to be exhibited and if you want your work to stand the test of time. If you intend to draw and then add colour washes, ensure you choose a pen with permanent ink, unless you are happy for it to run. But permanence does not guarantee archival quality. Read the small print and ask to ensure that they are suitable for what you want to do.

Dip pens and **fountain pens** offer another route. They both come with a range of nibs from fine to broad, and have the advantage of not being disposable. The nibs of dip pens are easily changed by removing them from the holder, but maybe aren't as convenient as fountain pens or fineliners if you are drawing on the go. Fountain pens with flexible gold nibs, or with fude nibs, which are bent at an angle, can offer a variety of lines in a single stroke.

You will find drawings in these pages by artists using **ballpoint pens**, **bamboo pens** and **twigs**: at its simplest, pen and ink is about dipping an object in ink and making marks with it, sometimes with surprising and unexpected results. And **brushes** or refillable

brush pens can also play a part, either in activating an ink line on the page with water, or for applying washes of colour. As always, some pens will suit the way you work more than others. A change from your pen of choice may just open up an exciting and unexpected new avenue for your work to take.

JAMES HOBBS,
DRAWING THINGS
Medium: marker pen
Dimensions: 10 x 15 cm

Inks

Waterproof ink, such as India ink, is commonly used in pen and ink work. It can give deep black lines and marks that dry to a slight sheen, and leaves a permanent mark. India ink can be diluted to create a range of greys. Some manufacturers recommend diluting their ink with distilled water to prevent the ink separating, although few of the artists in this book say they do, using instead humble tap water without adverse effects.

Water-soluble inks come in a wide range of bright, mixable colours, and can be used with dip pens, fountain pens and brushes. Dye-based inks are not lightfast, and are therefore most suitable if they are for work that will be scanned or stored away from the light. Lightfast pigment-based inks are better suited for works to exhibit. Water-soluble ink may be reactivated on the page even when it has dried, which can be used to good effect.

Fountain pens shouldn't be used with waterproof inks such as India ink, as they can clog up the nib's feed systems. If you do use a waterproof ink in a fountain pen, flush out your pen after use, as you would with a brush, to maintain it in a good condition.

Paper

Your choice of paper can have a big influence on the way your pen and ink work looks. Some of this is down to personal preference. A smooth-surfaced paper, such as a cartridge paper or hot press watercolour paper, is popular with those using pen and ink as it allows the nib to glide across the page more easily than papers with a more pronounced texture, and less ink is absorbed into the paper. Heavier papers, including cold press watercolour papers, may be more suitable if you tend to work with washes and like the effects created

JAMES HOBBS, FROM BLACKFRIARS BRIDGE
Medium: marker pen and ink
Dimensions: 10 x 30 cm

by pigment settling into the paper's undulations, but very thin paper can also create interesting results.

Sketchbooks go well with pen and ink because of their portability: it's possible to go out with everything you need to draw in your back pocket. Sketchbooks with paper of around 80 gsm will handle pen work, but again, heavier paper – sold as watercolour sketchbooks – will be better for work that embraces washes or watercolour. Paper comes in a range of colours also, such as white, cream and brightly coloured. Experimentation and experience will lead you to a combination of pen, ink and paper that fits the way you work.

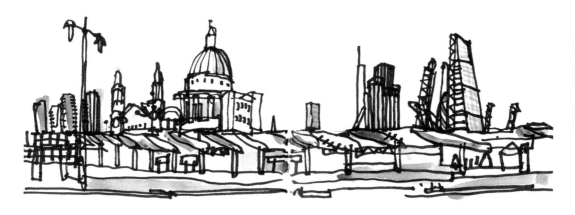

Drawing with ink

Given a pen and paper, we will inevitably turn to drawing a line. It is the most straightforward response and yet one that gives away a lot about us, like a signature. Lines can be confident or tentative, faint or bold, thick or thin. They can follow the outline of a subject, or describe its contours. They can be smudged or crisp, scribbled or considered. They can lead our eye around a drawing. A line can be extravagantly simple.

Terms that are closely related to drawing with pen and ink include **hatching**, which creates tone through parallel lines being drawn closely together: the closer the lines, the darker the tone. **Cross-hatching** does the same except sets of parallel lines are drawn across each other to create a grid and a darker tone. **Stippling** is the act of creating pointillist patterns and tones by small dots. But these are only the beginning. There is an unending array of stabs, flicks, dashes and gestural sweeps that can be employed with pen and ink. They can be determined, as with lines, by what we are

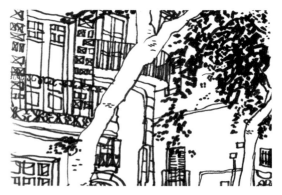

drawing with, and on what surface. The same mark on a large drawing and a small drawing can have a very different effect.

JAMES HOBBS, GIRONA, SPAIN
Medium: marker pen
Dimensions: 15 x 20 cm

202

Washes

A range of shades of grey can be created by adding water or distilled water to black inks. Applied with a brush, ideally on a watercolour paper that will cope with the buckling that may ensue, these washes can be built up on each other to create darker tones. Adding a wash over a previous one that has had time to dry effectively doubles the tone of the one beneath it, a process that can be continued as required to attain a rich variety of tones. Washes with coloured inks or watercolour can also bring a new dimension.

Adding more ink to paper that is still wet will create another range of outcomes. Pigments blur and blend in ways that depend upon the wetness of the surface, the intensity of the ink that is added, the means by which it is added, the angle at which the paper is held and more. There is an element of happy accident about a wet-in-wet approach as marks, drips and washes bleed into each other.

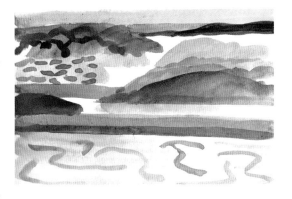

JAMES HOBBS, GURTEEN BEACH, IRELAND
Medium: black and blue inks
Dimensions: 15 x 20 cm

Artist index

Ch'ng Kiah Kiean; 30, 68, 134, 142, 194
(Malaysia)
kiahkiean.com

Chris Lee; 5, 92, 190
(United Kingdom)
chrisleedrawing.co.uk

Dalit Leon; 58, 128
(United Kingdom)
dalitleon.com

Michael Lukyniuk; 64
(Canada)
michaelsscroll.blogspot.ca

Fred Lynch; 54, 78, 170
(United States)
fredlynch.com

Joe Munro; 160
(United Kingdom)
joemunro.com

Fraser Scarfe; 62, 114, 124
(United Kingdom)
fraserscarfe.co.uk

Rolf Schroeter; 20, 28, 110
(Germany)
skizzenblog.rolfschroeter.com

Suhita Shirodkar; 26
(United States)
sketchaway.wordpress.com

Mike Slaton; 36, 40, 70, 82
(United States)
mikeslaton.culturalspot.org/home

Swasky; 16, 44, 48, 174, 196
(Spain)
swasky.es

Susan Toplitz; 96
(United States)
flickr.com/photos/52358552@N06/

Patrick Vale; 74
(United Kingdom)
patrickvale.co.uk

Wendy Winfield; 88, 94, 138, 168
(United Kingdom)
wendywinfield.com

NICHOLAS DI GENOVA, CROW
Medium: dip pen and India ink
Dimensions: 8 x 10 cm

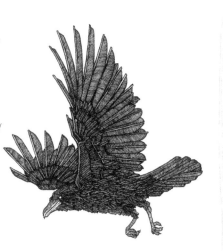

Index

Acknowledgements

I am grateful to all of the artists who have so kindly allowed me to use their images in this book, and generously shared their knowledge and experience.

My thanks to the RotoVision team who have been, again, great to work with: Isheeta Mustafi, Tamsin Richardson and Nick Jones. Thank you also to Gabriel Campanario and Isabel Carmona for their expert advice on the technical sections of this book.

Special thanks go to my father, Austin Hobbs, for a lifetime of support, and, as always, my love and thanks to Naomi, Esther and Celia, who make everything possible.